IMAGES
of America

RED LODGE

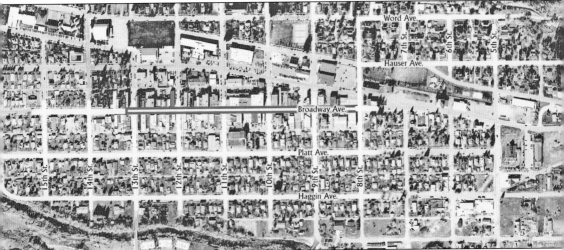

This 2007 aerial map shows central Red Lodge, what is now the city's historic district. At the bottom of the picture is Rock Creek, flowing north to the right. Between Rock Creek and Broadway Avenue is Finn Town, including several older houses along Haggin and Platt Avenues. The central business district, on what is now called Broadway Avenue, is highlighted with a bar. Just above that is Oakes Street, which would develop as a secondary main street and home to service enterprises such as a blacksmith, livery, and laundry. The railroad tracks ran at a diagonal, ending about Sixteenth Street (a path now occupied by larger buildings). In the upper right corner is the Hi-Bug neighborhood along Hauser and Word Avenues, now dominated by trees. (Map by Kari Clayton, courtesy Carbon County Historical Society.)

IMAGES
of America

RED LODGE

John Clayton and the
Carbon County Historical Society

ARCADIA
PUBLISHING

Published by Arcadia Publishing
Charleston, South Carolina

Printed in the United States of America

Library of Congress Catalog Card Number: 2007940251

For all general information contact Arcadia Publishing at:
Telephone 843-853-2070
Fax 843-853-0044
E-mail sales@arcadiapublishing.com
For customer service and orders:
Toll-Free 1-888-313-2665

Visit us on the Internet at www.arcadiapublishing.com

To the people of Red Lodge

CONTENTS

ACKNOWLEDGMENTS

This book exists because the staff of the Carbon County Historical Society decided to make photographs in their collection available in book form. All photographs in this book are copyrighted by the society, with the exception of those noted "Courtesy . . . ," for which the original owners may retain copyright. For choosing me to structure and write the book, and for their assistance in scanning photographs, locating information, providing context, and offering advice, I'd like to thank executive director Penny Redli and staffers Tressa McGregor, Patty Hooker, and Joel Bertolino. For donation of additional pictures, thanks to Merv Coleman (www.colemangallery.biz), Rob Ringer (www.redlodgemountain.com), Jael Kampfe (www.lazyel.com), Betsy Scanlin, Liza and Doug McClelland, Tressa Fahrenthold, Eileen Stonebreaker, and Ernie Strum. For reviews of the manuscript that caught several inconsistencies, thanks to Penny Redli, Bob Moran, Tom Flaherty, Tom Ringley, and Kari Clayton. For a well-designed editorial process and strong, friendly, fast, and consistent help, thanks to editor Hannah Carney and the staff at Arcadia Publishing. For compiling the comprehensive source on local history, *Red Lodge: Saga of a Western Area*, thanks to Shirley Zupan and Harry Owens. For beverages enhancing the quality of life, thanks to Red Lodge Ales. For support, wisdom, humor, good taste, and other magnificent qualities too numerous to mention, thanks in the form of my undying love to Kari Clayton. Most importantly, I'd like to thank the people (past and present) of Red Lodge for supporting this project, for donating photographs to the museum (www.carboncountyhistory.com), and most especially for creating and sustaining such a strong, vibrant, character-filled community.

INTRODUCTION

Whether it's coal mining, architecture, natural splendor, or pink elephants, Red Lodge history has something for everyone. At the foot of the Beartooth Mountains, the city developed in the 1880s for the purpose of mining coal. In contrast to the ranching that powered much of the region, coal mining fostered an urban environment, with compact neighborhoods and a vibrant brick downtown. Jobs in the mines attracted diverse immigrants, including Finns, Italians, Scots, Irish, and Yugoslavians. As city population neared 5,000 after the beginning of the 20th century, the groups settled in distinct neighborhoods that preserved their ethnic traditions.

And then, like a ghost town, Red Lodge faded. The area's underground coal mines proved more expensive than strip-mined coal in eastern Montana—especially when factoring in the labor costs in this heavily unionized city. A truly devastating blow to area coal mining came in 1943, when an explosion at neighboring Bearcreek's Smith Mine trapped and killed 74 miners, the worst coal-mining disaster in Montana's history.

Yet Red Lodge did not become a ghost town. Community leaders turned to agriculture and tourism to preserve their lives in this remote but scenic spot. Dude ranching became a popular way for wealthy easterners to see the Rockies, and Red Lodge's Al Croonquist led the national Dude Rancher's Association while working to stock mountain lakes with trout. Meanwhile, Dr. J. C. F. Siegfriedt and newspaper publisher O. H. P. Shelley promoted the idea of a high road through those mountains to Yellowstone National Park. Construction of the Beartooth Highway, which Charles Kuralt once called the most scenic highway in America, was completed in 1936.

Every Fourth of July, the Red Lodge Home of Champions rodeo celebrates the legacy of the riding Greenough family and famous Linderman brothers. Every August, the Festival of Nations celebrates the ethnic diversity of the old coal mining city. And for several years, every summer the Top of the World Bar would celebrate the opening of the Beartooth Highway by handing out drinks, one year also displaying an elephant tinted pink. As new generations of tourists and immigrants discover skiing at Red Lodge Mountain, hiking in the Absaroka-Beartooth Wilderness, horseback riding, golf, and fishing, Red Lodge's history provides a heritage to match the scenery.

Although the economy of Red Lodge has evolved, the character of the community remains unique. Set in a brutal high-altitude environment that requires hard work to even survive, Red Lodge has always held a tolerance and even admiration for the unusual traits of the gritty folks who could tough out the conditions. John "Liver-Eatin' " Johnston may have been the hero of a highly fictionalized Robert Redford movie, but in Red Lodge he's celebrated more as an irascible town constable. Calamity Jane may have been the heroine of highly fictionalized dime novels, but in Red Lodge she was known for her generosity and great cheer. Noncelebrities—from "Packsaddle Ben" Greenough to "Jimmy Joe" Ayling—became local legends because of their unique talents or character and especially because of their love of the region.

This book tries to build a portrait of that history and that community by collecting photographs from almost every era and segment of its past. It starts with some images of the natural setting and pre-European history (though these images are necessarily sparse, since there were no

photographers here to record them). It shows the operations of the coal mines, once the largest in the state. It chronicles the development of the downtown area, including some of the remarkable architecture that even today remains a distinctive calling card of the community. It samples the various neighborhoods, with their distinctive traits like neighborhoods in a large city. It includes some extraordinary, rarely seen photographs of the construction of the Beartooth Highway into Yellowstone, an effort of not just local but regional and national significance. It investigates the role of agriculture in the surrounding area, including cattle ranching and the rodeo tradition that came out of it. It looks also at the tradition of the Festival of Nations, which used ethnic diversity to bring the community together rather than split it apart. It outlines the beginnings of tourism in Red Lodge, including rarely published photographs of the Camp Senia dude ranch and the early years of Red Lodge Mountain ski resort. And it concludes with a gallery of Red Lodge characters, with brief descriptions of what made them special.

This last chapter was unquestionably the most fun to put together, and yet is also the most incomplete. There were characters for whom the Carbon County Historical Society and Museum didn't have sufficient images, and images for which the stories couldn't be sufficiently remembered. There are undoubtedly people we simply—yet unfairly—forgot. And there are, of course, the continuing parade of characters, those who gain sustenance from the mountains or the snow or community that surrounds them. These are the characters who are making the next generation of Red Lodge history, which we can all hope proves as rich as the last ones.

One

PREHISTORY

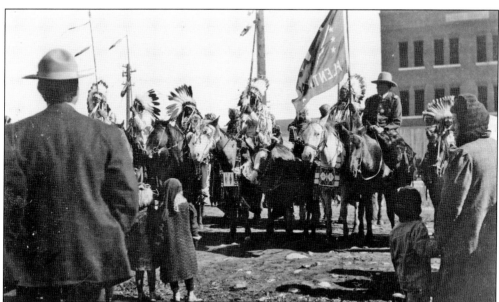

Plenty Coups was the last of the traditional Crow chiefs. The Red Lodge area was once part of the Crow Indian Reservation; evidence that Crows hunted and fished here includes arrowheads, stone tools, and tepee rings. This picture shows the chief (second horseman from right, holding flag) in Red Lodge in 1909. Plenty Coos (as he spelled his name) once told his people, "Education is your greatest weapon. With education you are the white man's equal, without education you are his victim and so shall remain all of your lives."

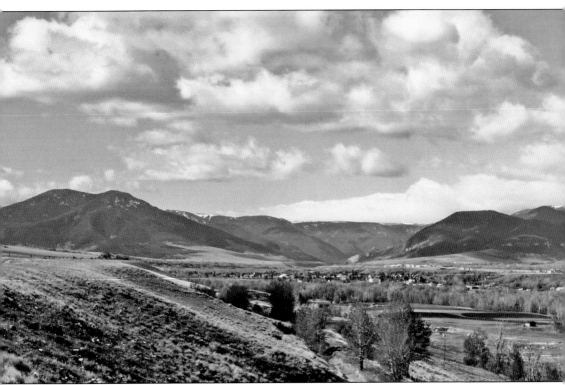

This panorama looks southwest at the Beartooth Mountains from a point about 3 miles north of Red Lodge. From left to right are the twin-topped Mount Maurice (elevation 9,262 feet), the valley of the main fork of Rock Creek, and flat-topped Towne Point (elevation 7,966 feet). Downtown Red Lodge (elevation 5,555 feet) is just below and to the left of Towne Point, nestled in the valley between the East and West Benches. In this view, it is largely hidden by trees. At the far right of

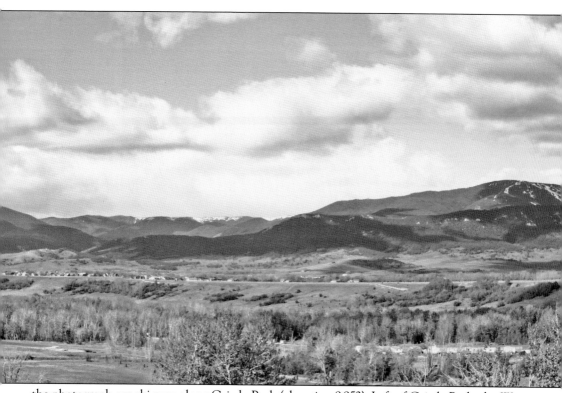

the photograph are ski runs along Grizzly Peak (elevation 9,952). Left of Grizzly Peak, the West Fork of Rock Creek rises to the Silver Run and Hellroaring Plateaus. These mountains—their minerals, water, transportation challenges, natural beauty, and brutal weather—have long shaped the history of the town. (Courtesy Merv Coleman, Coleman Gallery.)

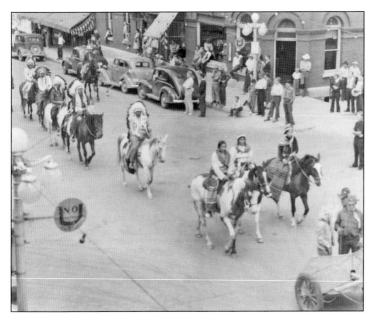

Over the decades, Crow Indians have frequently participated in Red Lodge culture, though often as novelties and only rarely as full-time residents of the city. This picture, probably from the 1930s, shows the Native American entry in full regalia in the Fourth of July parade. Crows often came to town for the entire holiday weekend, setting up camp on the rodeo grounds west of the grandstand and participating in races and events.

This 1895 picture, obviously posed, was taken a few miles below (north of) Red Lodge. It is labeled "Renegade Cree Indian Camp." Though the area was no longer part of the reservation, Native Americans did occasionally travel through Carbon County into the 1920s. In this case, "renegade Cree" may refer to the Métis people, members of a mixed-blood culture largely descended from French trappers and their Cree brides.

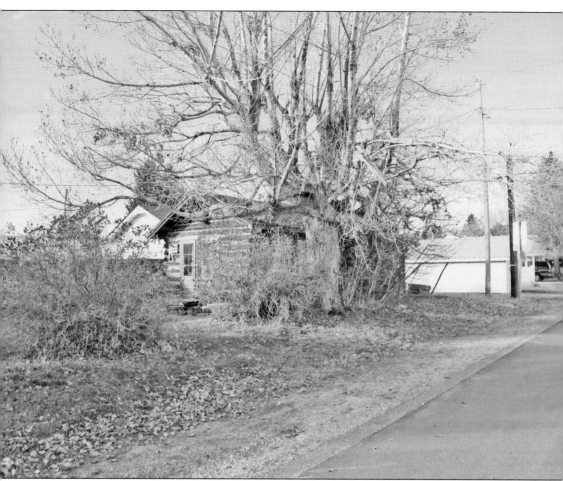

Edward Earl (E. E.) Van Dyke (c. 1869–1947), an old-style mountain man, constructed one of the first buildings in Red Lodge. It is shown in this 2007 photograph nearly overwhelmed by an adjacent tree. Van Dyke started his working life in the mines at Cooke City, where he was also once arrested for poaching inside Yellowstone National Park, but he soon became better known as a guide. In 1883, he and his father blazed a trail from Cooke City to Red Lodge. Remnants of the Van Dyke Trail, with rock monuments marking the path, are still visible today from the Beartooth Highway. Van Dyke also guided a survey crew mapping out boundaries of the Crow Reservation and later began a big-game hunting service. (Author's collection.)

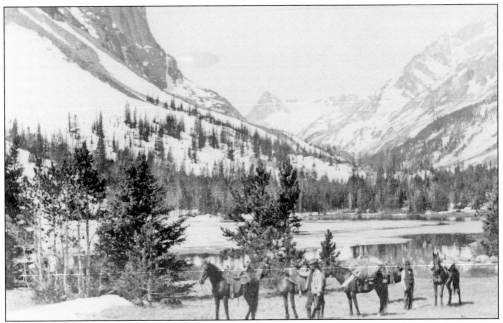

The Beartooth Mountains have always been both forbidding in their ruggedness and tempting in their beauty. Here a party from the Dilworth Ranch has taken a horse-packing trip into the mountains. In 1882, Gen. Philip Sheridan led one of the earliest Euro-American forays through the Beartooths. His 124-person party went from Cooke City to the approximate site of the current Sheridan campground, about 8 miles south of Red Lodge.

With few settlers, and most of them traveling by horse, roads were less significant than today, as evidenced by this view of the Point of Rocks, about three miles south of Red Lodge. At left is Rock Creek. As early as 1836, fur trappers had named this stream the Rocky Fork. The name Rock Creek came into use starting in 1869 and became standard after 1897.

14

Two

COAL

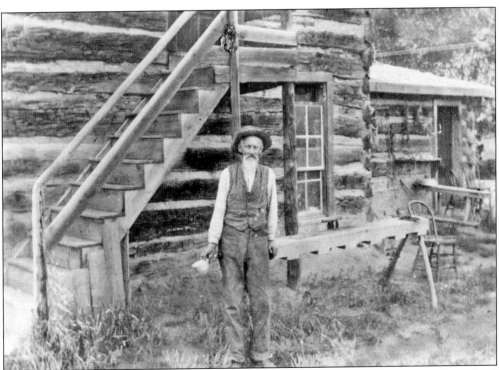

"Yankee Jim" George, a pioneer hunter and prospector in southern Montana, is generally credited with discovering coal outcroppings east of Rock Creek in 1866. George alerted two Bozeman men who started organizing what would become the Rocky Fork Coal Company, but it would be 21 years before the company started mining here and another two years before completion of the Rocky Fork and Cooke City Railway. George is pictured here in later years at his way station above a canyon named after him north of Gardiner.

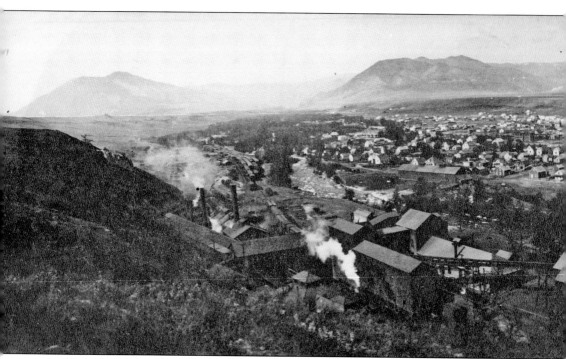

In this undated view from the heyday of coal mining, the location of the mines in relation to the city is visible. The view looks west and slightly south across Red Lodge from the East Bench between Twelfth and Thirteenth Streets. At left is the East Side Mine (also known as the Rocky Fork Coal Company Mine), the first and largest in town. Mining began here in 1887, and by 1891, employment reached 400. In 1898, the Northern Pacific Railway took control, operating the mine

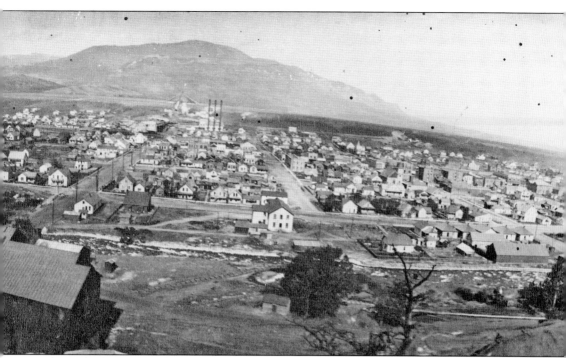

under a subsidiary called the Northwest Improvement Company. To the far left, partially obscured by smoke, is the prop yard, where timbers used in the mine tunnels were stored. Loggers felled trees up-canyon and floated them down Rock Creek during spring high water to a millpond and sawmill near the current Bearcreek bridge. Across town are three smokestacks between Twelfth and Thirteenth Streets, directly under Grizzly Peak. This is the West Side Mine, opened in 1907.

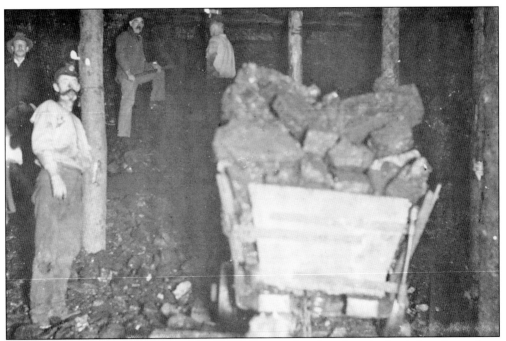

In this picture, probably from 1896, a miner has a car of coal ready to be hauled to the surface. Shafts followed seams of coal up to 2 miles from the entrance. In the early days, there was no electricity in the shafts, and of course the coal was mined with non-motorized tools.

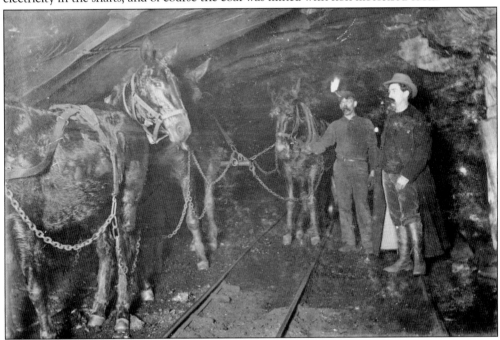

Two men are pictured in December 1896 with the mules that powered the coal mines. Before 1910, fifty to sixty horses and mules provided the power for the mine cars. After about 1910, the animals were replaced by electric motors, though they were still used in the timber yard for many years thereafter.

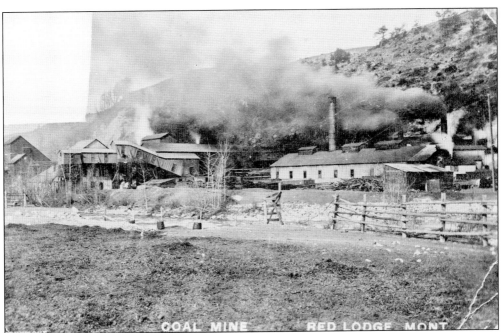

The buildings of the East Side Mine are seen in a picture taken from the barnyard east of Rock Creek where the mules were housed. The smoke that obscures the center of the picture was a common phenomenon. Black coal dust from the mines' smokestacks coated the houses and people of town; even Rock Creek occasionally ran black.

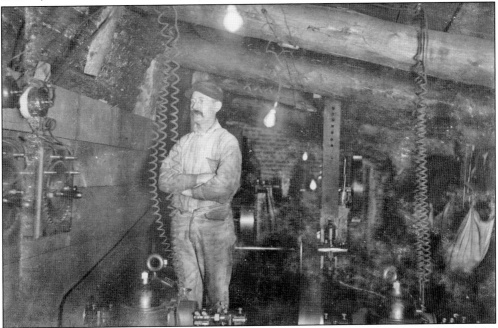

Mine employee Dan Sutherland is shown at the pump station on the sixth belowground level of the East Side Mine in 1896. The pumps kept seepage out of the mine tunnels. Unlike the individual placer mines of California's legendary forty-niners, Red Lodge coal mining was a large industrial operation. It required a heavy investment of capital and a concentrated workforce.

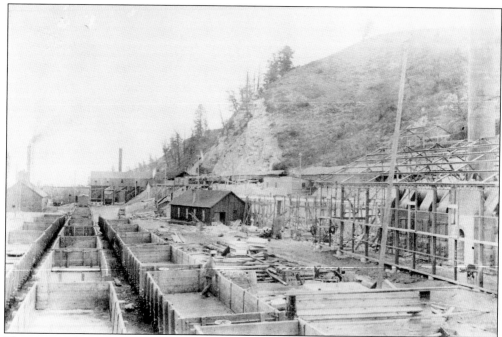

This picture shows the construction of the East Side tipple and boiler house in 1896 or 1897. The mines were constantly adding improvements as production and technology progressed.

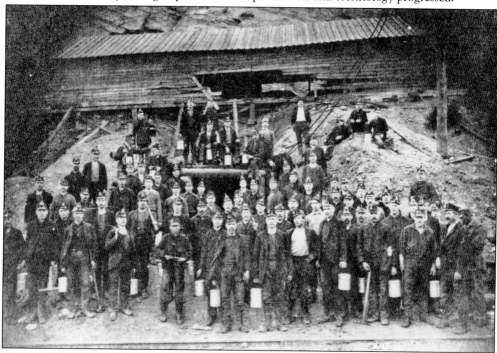

Miners gather at one of the entrances to the East Side Mine on Thirteenth Street in 1904. Mining was a male occupation. In 1900, sixty-five percent of Red Lodge's adult males worked the mines. In 1905, six hundred employees were producing 2,000 tons of coal per day. These numbers would increase substantially over the years.

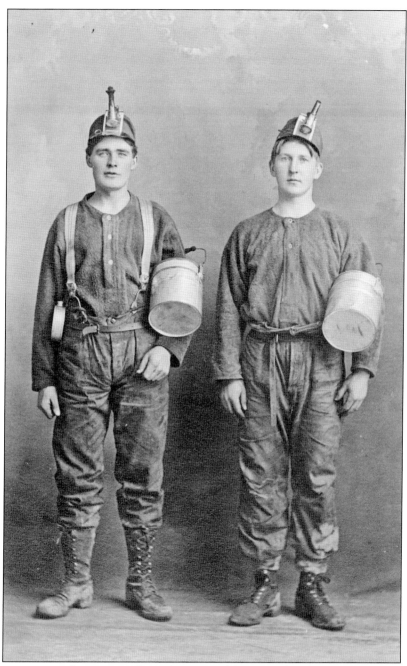

This close-up picture of two miners shows their typical dress. On their helmets are oil-based lamps. The lamps' open flames were a safety hazard given the potentially deadly gases (carbon monoxide, or "white damp;" carbonic oxide, or "black damp;" and methane, or "fire damp") in the mine shafts. When a miner's light flickered, he knew gas was present, and an animal (canary, mouse, dog, or cat) would be lowered to the shaft to test the air. The oil lamps were an improvement on miners' original illumination: candles, often homemade out of beeswax. Around 1912, the oil lamps were replaced by carbide lamps (also with an open flame); battery lamps would not reach Montana until the 1930s.

This view looking northeast from the West Bench shows the extent of industrial development by 1909, two years after the opening of the West Side Mine. To the left are its buildings and smokestacks. The trestle-like structure in the middle is its tipple, where cars were tipped and emptied of their coal. (It is currently the site of the civic center, built in 1950.) Also note the large slack pile above and to the right of the tipple. The area's coal was used for heating and cooking

throughout Montana, fed the furnaces of the Great Western Sugar Company in Billings, powered Northern Pacific locomotives, and fueled the gigantic copper smelter in Anaconda. They were the largest mines in the state. By this year, about 1,600 men worked in the city's mines, and Red Lodge's population was over 5,000.

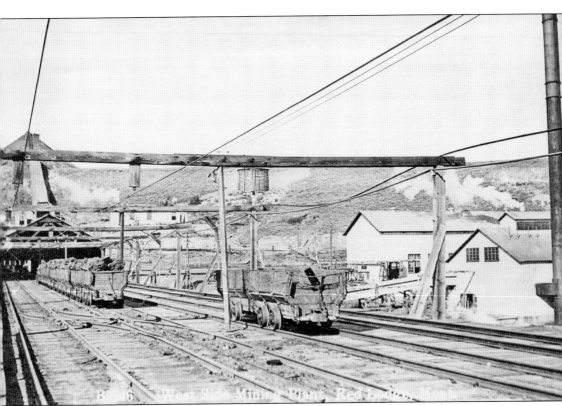

Railroad cars wait at the entrance to the West Side (or "Sunset") Mine, which was also run by the Northwest Improvement Company. By 1910, the two Red Lodge mines were shipping more than 12,000 carloads of coal per year. Several new mines were opening in Bearcreek, which had its own rail spur coming in from Belfry. From 1913 through 1917, Red Lodge produced more than a million tons of coal per year. But strikes in 1919 and 1922 troubled the Northwestern Improvement Company, which had also recently begun strip-mining operations in Colstrip. Meanwhile, households were switching from coal to electricity, natural gas, and other fuel sources. Citing high production costs, the company closed the West Side Mine in 1924 and also scaled down production on the East Side Mine, finally closing it in 1932. However, different companies continued mining a few miles east in Bearcreek and Washoe.

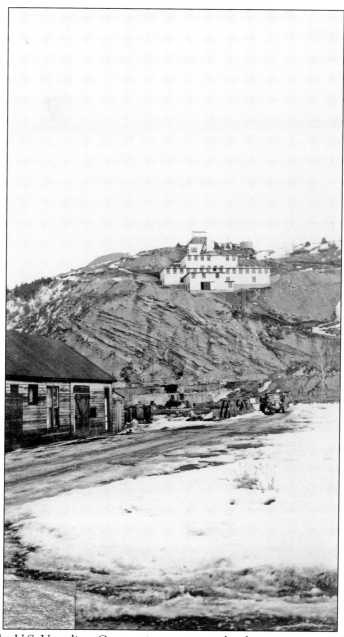

In the 1940s, the U.S. Vanadium Corporation constructed a chrome concentration mill on the site of the East Side Mine. The mill processed chromite mined near the Beartooth Highway's Mae West Curve and at the top of a new road constructed up the Hellroaring Plateau. The milled product, chrome, was used in iron and steel products to prevent rust and was in particular demand for munitions and battleships. Completed in 1942, the mill had a capacity of 450 tons per day. From March to November 1942, it turned out 11,689 tons of concentrate. Then the Allied forces reopened shipping lanes in the Atlantic Ocean, allowing the import of higher-grade African ore, and chrome operations here were shut down. This picture dates from prior to 1951, when the complex burned down. What is seen on the East Bench today is the foundation of this mill, not the coal mines.

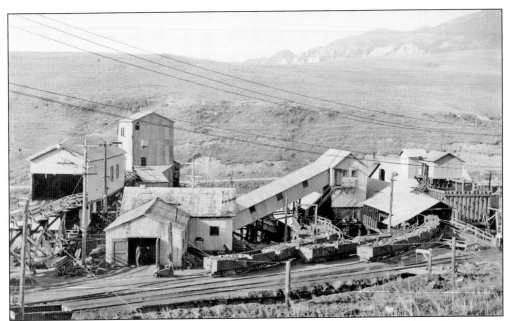

The Smith Mine Disaster, on February 27, 1943, in neighboring Bearcreek, killed 74 miners, many of whom had lived in Red Lodge. It was the worst coal-mining disaster in Montana history. After a powerful explosion of built-up methane, several miners barricaded themselves behind a door to keep the gases out. While waiting in vain to be rescued, they scrawled messages to their families on boards. This picture shows some of the Smith Mine buildings.

Even in the decades after the major mines closed, coal continued to play a role in Red Lodge. Widows remembered the Smith Mine Disaster, homes were heated by coal furnaces, and from certain vantage points slack piles dominated the viewshed. In this Merv Coleman aerial photograph, probably from the early 1980s, a huge black mass of coal slack sits atop the West Bench at center right. (Courtesy Merv Coleman, Coleman Gallery.)

Three

DOWNTOWN

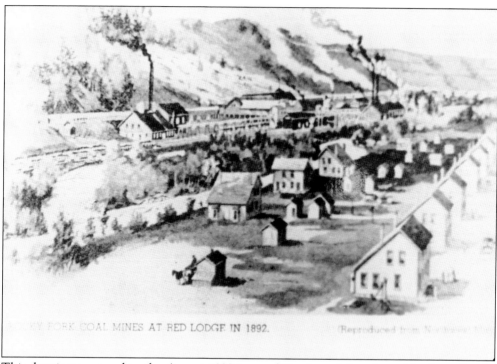

ROCKY FORK COAL MINES AT RED LODGE IN 1892.

This drawing appeared in the August 1892 issue of *Northwest Magazine*, a Northern Pacific booster publication. It shows the mines on the east side of Rock Creek under the East Bench. In the foreground are rows of saltbox-style houses. The magazine wrote, "Some of the men live with their families in neat and comfortable homes built by the coal company and others live in little log cottages of their own."

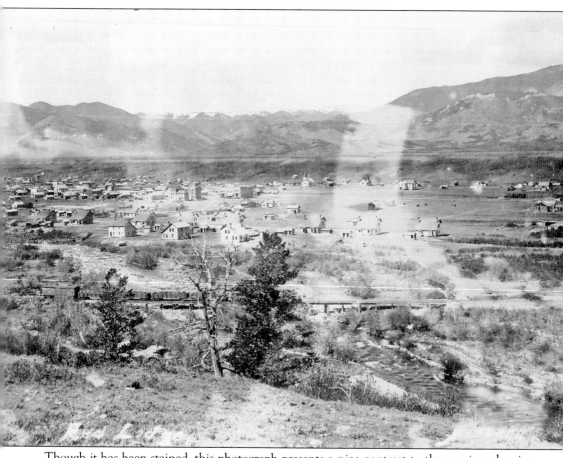

Though it has been stained, this photograph presents a nice contrast to the previous drawing. It was taken from the East Bench looking southwest across Rock Creek and the townsite in the late 1890s. In the foreground is the rail spur to the East Side Mine, crossing Rock Creek on "Big Engine Bridge" at about Eighth Street. On the other side of the creek are some of the saltbox houses depicted in the drawing. In the middle distance, two large brick structures, the Spofford Hotel and the Improvement Building, anchor an otherwise empty downtown. Most development is congregated to the left, in Old Town, Red Lodge's first downtown centered around the end of the railroad tracks at what is now Sixteenth Street. This neighborhood was a hodgepodge of poorly platted streets where people built houses on land that they couldn't prove they owned.

Another broad view looks south from the railroad passenger depot in 1895. Despite the dramatic setting against the mountains, few trees are in evidence. These old photographs also give a sense of how distinct neighborhoods once were. When upper-class families settled in "Hi-Bug" (to the right in this picture), they were physically set apart from Old Town, the "new" downtown, and the workers' housing near the East Side Mine entrance.

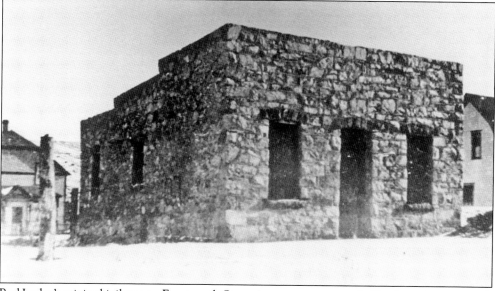

Red Lodge's original jail was on Fourteenth Street in a spot now occupied by the swimming pool. This was the location of the only legal execution in Carbon County history. In January 1899, Thomas Salmon was hanged for the murder of William O'Connor, Red Lodge's first mayor and a superintendent at the coal mine. Salmon, a union activist who may have also been in love with O'Connor's wife, ended an argument with his derringer pistol. Four months later, the black-edged invitations were issued for his hanging.

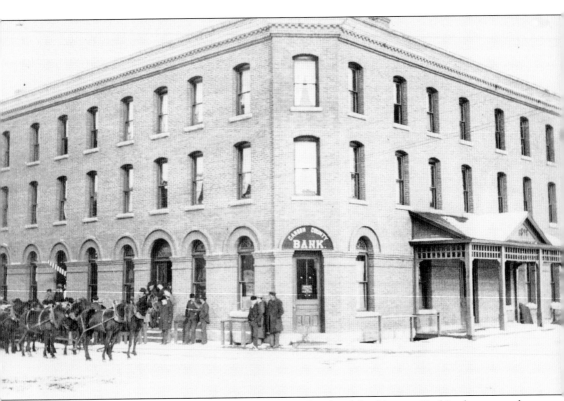

The first building in the new downtown—and the first brick building in Red Lodge—was the Spofford Hotel, constructed in 1893. The Rocky Fork Town and Electric Company, which like the mine was controlled by banker Samuel Hauser, Northern Pacific Railroad president Henry Villard, and former Northern Pacific president Frederick Billings, built the hotel halfway between Old Town and the train depot. This picture shows the main entrance on the southern (Eleventh Street) side of the hotel: because this was the first building in the neighborhood, they didn't know which street would become the downtown thoroughfare. This photograph is also notable for the people congregated around the horses on Billings Avenue (now Broadway Avenue): the party of William F. "Buffalo Bill" Cody visiting Red Lodge on November 19, 1896. The Spofford was renamed the Pollard with its purchase by Thomas F. Pollard in 1902.

In another 1896 view of the Spofford Hotel, the old "bus" (a horse-drawn wagon) brings passengers to the hotel from the train depot three blocks north. Furnished in pine, hand-oiled, and costing very close to $20,000 ($430,000 in 2006 dollars), the Spofford was the premier place for visitors to stay. With a spacious lobby, dining room, bar, bowling alley, and barbershop, it was the place also for locals to gather.

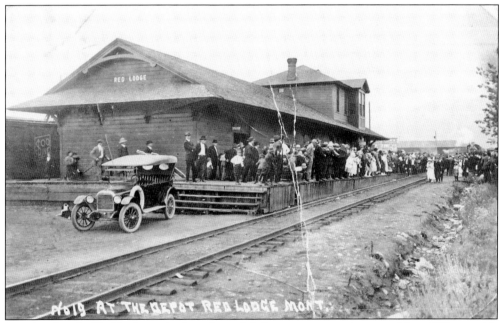

In its heyday, the Red Lodge train depot hosted daily passenger service to and from Billings, with stops in Roberts, Carbonado, Joliet, Silesia, Mason, Laurel, and Foster. Pictured here in the 1920s, it had a furnished upstairs apartment for the station agent. Passenger service was discontinued by the early 1940s, and later the remodeled depot became home to the Carbon County Arts Guild.

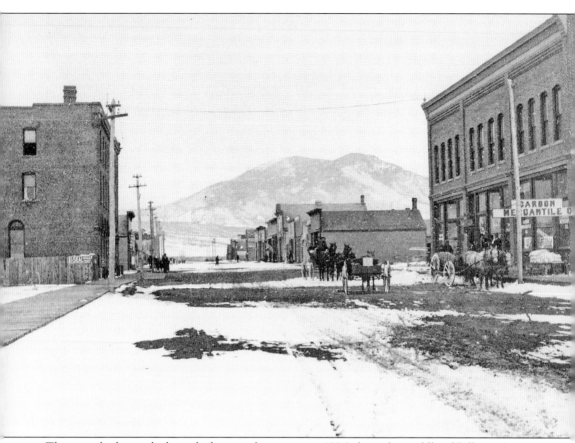

This view looks south through the new downtown in 1896 along the middle of Billings Avenue (named after Frederick Billings of the Northern Pacific, and in 1912 renamed Broadway Avenue to avoid confusion with the city of Billings), just a bit south of Tenth Street. On the left is the north face of the Spofford Hotel. On the right is the Improvement Building. Note that the booming village—named county seat of newly created Carbon County in 1895—has board sidewalks and a row of electric poles on the east side of the street. One new arrival commented that it seemed only young people lived in town. Most were miners, and money was plentiful.

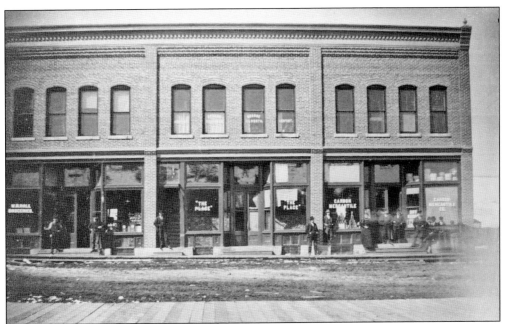

This picture provides a head-on 1896 view of the Improvement Building, constructed by the Northwest Improvement Company, the Northern Pacific subsidiary that ran the coal mines and much else in Red Lodge after 1902. On the right is the Carbon Mercantile Company. In the middle is a saloon called the Place.

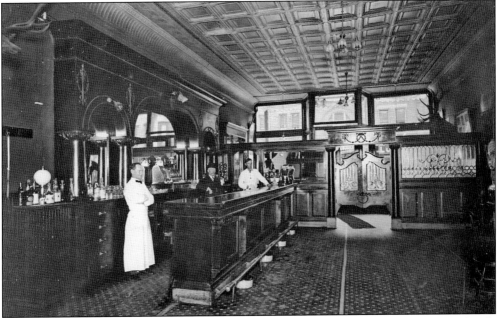

Inside, the Place saloon was a richly decorated spot of luxury. Tin ceilings, tile floors, and well-dressed staff identified this as a sophisticated urban place, in contrast to the dusty cowboy saloons of the rural West. Red Lodge was always known as a hard-drinking community, and this was one of about 20 saloons in town. Like most of the saloons, it had a footrail but no stools and was primarily a male establishment.

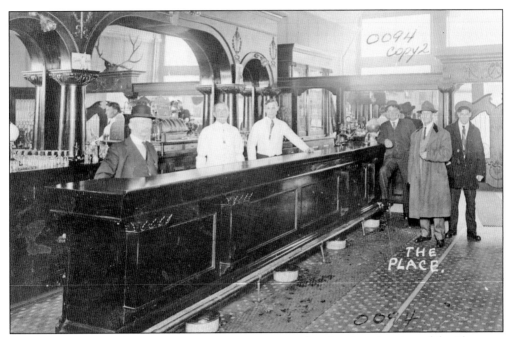

Another interior view of the Place shows its intricate backbar. Such feats of woodworking were a form of public sculpture in their day. Most of the Red Lodge saloons were ethnic in character, and the Place catered to the English and Irish clientele. William Larkin, one of its owners, also served as fire chief, mayor, and president of the U.S. National Bank.

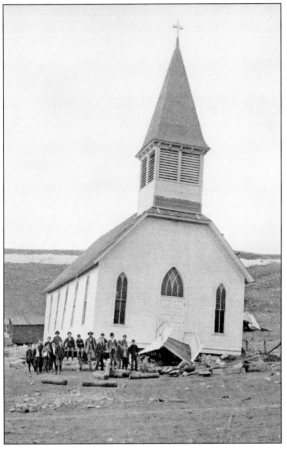

In addition to mine buildings, settlers in the new city constructed stores, houses, and churches. This picture shows the recently constructed St. Agnes Catholic Church after an 1896 wind storm blew it off its foundation. After church members reset it on the foundation, the building survived into the 1990s, when it was replaced by a larger structure.

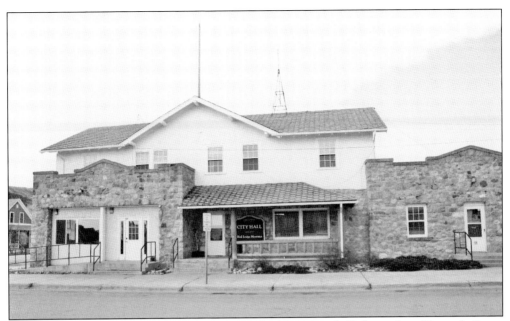

At left, the easternmost fieldstone wing of this building (city hall, located on Eleventh Street near the hotel) was constructed as a fire hall in 1898, the first civic building in town. City offices (the central section) were added in 1901, and the western wing and second story were added by 1939 in a format designed to match the historic original. A 1990s renovation moved the council chambers to the eastern wing. (Author's collection.)

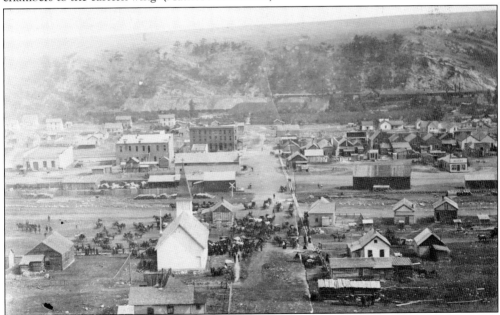

This view of downtown, probably showing the 1898 funeral of William O'Connor, looks east along Eleventh Street from a spot on the West Bench. In the foreground is the Catholic church. In the middle distance, on the left of Eleventh Street, is the Spofford Hotel. Left of the hotel is the back side of the Improvement Building. To the back right, residences are congregated around the Thirteenth Street entrance to the East Side Mine.

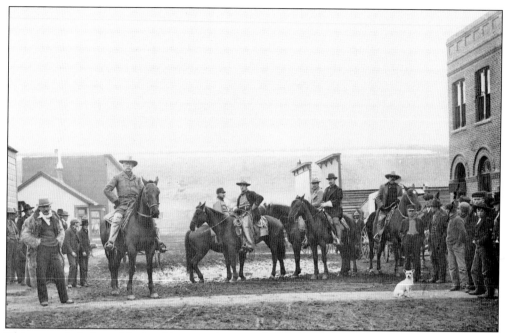

This expanded view of the book's cover photograph shows an additional figure. The man on the leftmost horse, looking directly at the photographer, is Gen. Nelson Miles. As noted on page 2, also present are William F. "Buffalo Bill" Cody and painter Frederic Remington. At right is a portion of the Carbon County Bank, which still stands at Eleventh Street and Broadway Avenue.

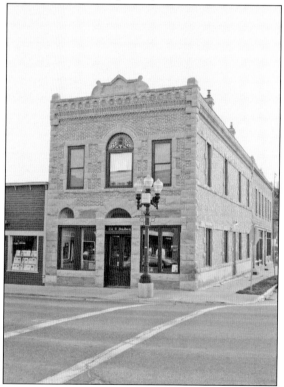

This grand brick building housing the Red Lodge State Bank was constructed at Broadway Avenue and Twelfth Street in 1901. This 2007 photograph highlights a historic restoration completed in the previous year. Note the impression of elegance brought about by the sandstone accents, arched transom, and articulated cornice. A 1909 rear addition to the structure included a restaurant on maple flooring, unusual in a town where most old floors were Douglas fir. (Author's collection.)

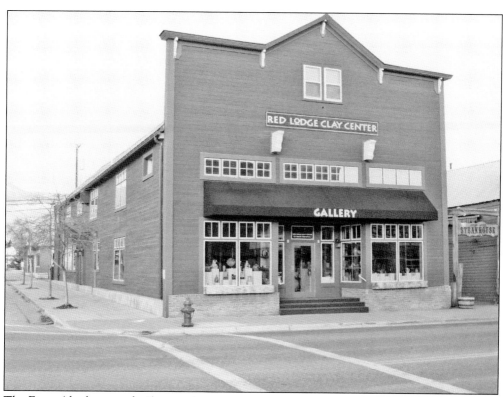

The Finns (the largest ethnic group in Red Lodge, comprising about a quarter of the population in 1900) built an opera house for meetings, dramatic works, prizefights, wrestling matches, and other events. At the corner of Broadway Avenue and Thirteenth Street, it was completed in 1898. The photograph above shows the extensively remodeled building housing the Red Lodge Clay Center in 2007. The photograph at right is an undated postcard of costumed performers in a play called *Tunkkarin Joonas*. The addition of electric footlights on the stage in 1907 made this building the preferred stop for traveling theatrical troupes.

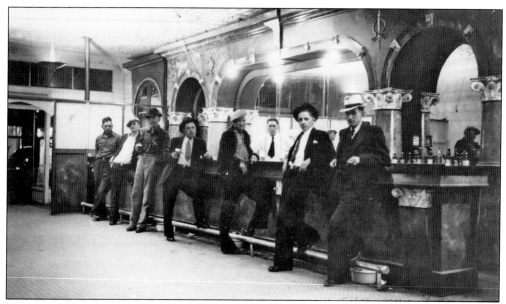

This undated picture shows men lined up at the Mint Bar. Today many Red Lodge establishments have preserved their historic interiors; for example, the Mint (now the Snag) still has this tin ceiling and intricate backbar. Ironically, when they were first installed, mass-produced metal ceilings were scoffed at by Eastern architectural critics. Such "sheet iron elegance" was allegedly a cheap attempt to present a delusional facade of urbanity in backwater rural areas. Today, however, they are admired for historically elegant craftsmanship.

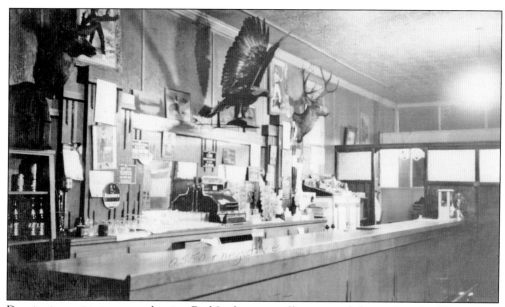

Despite its aspirations to urbanity, Red Lodge was still very much located in the West. Thus taxidermy also played an important decorative role in gathering places such as taverns. In this picture of Newman's Corner (a bar on the corner of Eleventh Street and Broadway Avenue, now occupied by a parking lot), the ornate tin ceiling is paired with a deer head, a stuffed bird, and a boxing picture on the wall.

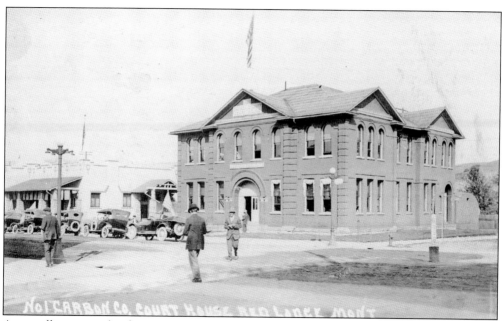

No l CARBON CO. COURT HOUSE RED LODGE MONT

An excellent example of restrained public building design with classical detailing, the Carbon County Courthouse at Broadway Avenue and Tenth Street (above) was designed by Butte architect P. J. Donohue. Note how the round-headed second-story windows echo the central arched entrance. Today the building remains close to its original form, except for wings on the north and south sides. Back by the alley, and hidden from sight in this view, was the new jail, constructed in 1903. The interior included a sheriff's office, a women's cell, and series of cages for male prisoners. This jail remained in use until 2001. Inside the sheriff's office (right), deputy Johnny Clark Walker is seated at the sheriff's desk. The old oak rolltop desk remained in use by Carbon County sheriffs until it was donated to the historical society in 2007.

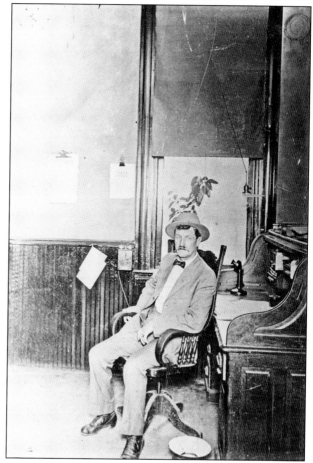

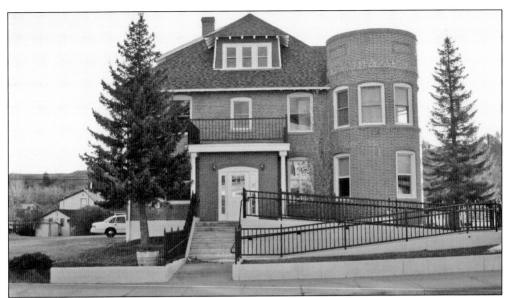

The Mount Maurice Hospital, constructed in 1909, could house up to 50 patients under the care of Dr. S. M. Sounders, whose family also lived on the first floor. The building once had an elaborate porch, not shown in this 2007 view that depicts a newer vintage handicapped access ramp. The interior has served as county offices since 1954. (Author's collection.)

The Savoy Hotel was constructed in 1907. With its location just one block from the railroad passenger depot, it offered travelers an alternative to the Pollard Hotel. Despite its elegance, the hotel struggled and in 1913 was sold for back taxes. It was later used as a rooming house and contained the town's post office and first library. This 2007 photograph shows the building in its current use as a funeral home. (Author's collection.)

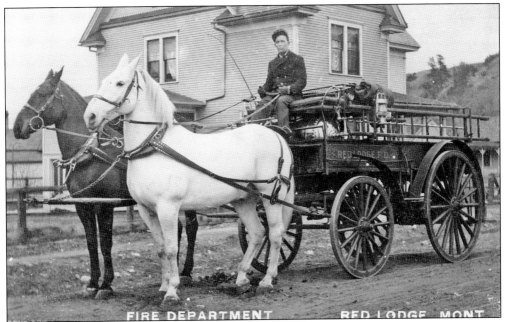

Following a devastating downtown fire in March 1900, Red Lodge organized a volunteer firefighting force. The membership fee was $1, and members were limited to 50. In 1904, the department purchased its first fire team and hose wagon, shown here. The city's first motorized fire truck would not come along until after 1916.

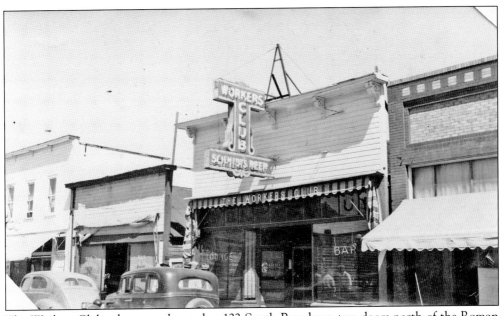

The Workers Club saloon was located at 122 South Broadway, two doors north of the Roman Theater. Subsisting on soft drinks and cards during Prohibition, it became a bar and lounge from 1934 to 1947, run by Bert and Dominic Castellano. Later, when run by the Klepich family, it was renamed the Wagon Wheel.

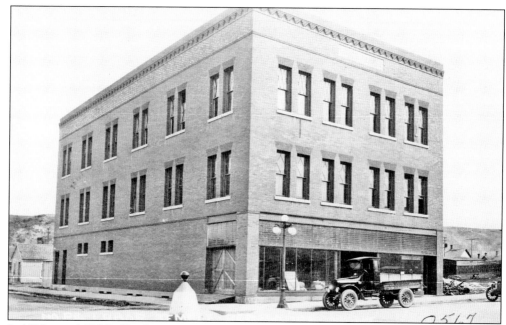

In 1909, over 1,000 Red Lodge union miners constructed the three-story Labor Temple for $36,000 ($780,000 in 2006 dollars). The ground floor of the state's first labor temple housed a mercantile and restaurant; the second floor housed offices, a library, a saloon, and showers; and the third floor housed a ballroom. In 1989, an anonymous donor gave the building to the Carbon County Historical Society and Museum.

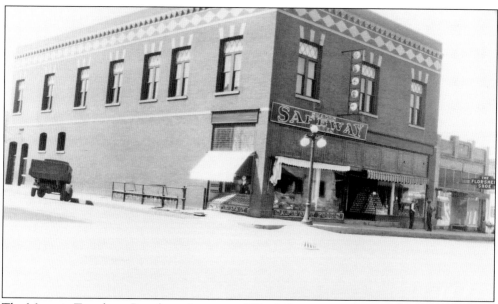

The Masonic Temple, at Broadway Avenue and Tenth Street, was also completed in 1909. The first floor has always been devoted to retail. After the Safeway grocery store pictured here (perhaps in the late 1920s), later occupants included Sawyers grocery, a hardware store, and the Kibler and Kirch furniture showroom.

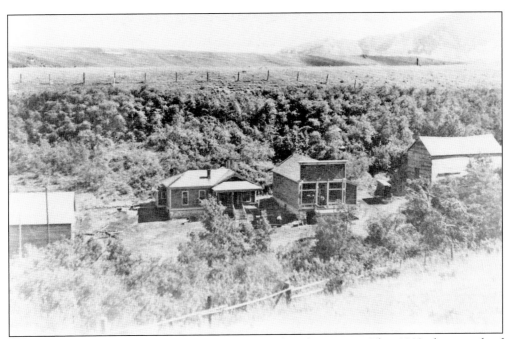

Not all businesses in the early years were confined to downtown. This 1903 photograph of Brewery Hill (the current Highway 78 toward the golf course) shows Dan Davis's beer garden second from the left. A newspaper advertisement that year noted that the garden offered "Pabst and Anheuser-Busch beer, rye whiskey, wines on tap, and a pleasant place to sit out under the bushes and enjoy yourself."

At the north end of town, the brewing Lehrkind family built a four-story brick brewing plant in 1910. Fred Lehrkind said, "The chief object that attracted me to Red Lodge was the most excellent water supply here. . . . Without good water, good beer cannot be made." The brewery's capacity was 35,000 barrels per year. It was closed by Prohibition in 1918 and later became a pea cannery.

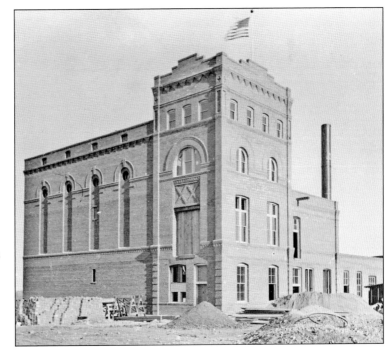

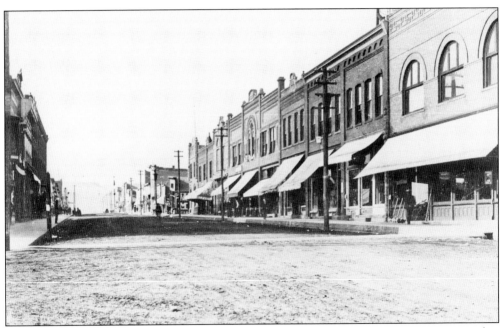

By 1909, the downtown area had filled out to something quite akin to its current state, with a progression of brick buildings and awnings marching down the street toward Mount Maurice. Almost every building boasted unique decorative touches, such as the rounded windows and brick detailing evident in these buildings on the western side of Broadway Avenue between Tenth and Eleventh Streets. Today this is one of the most well-preserved blocks in the state.

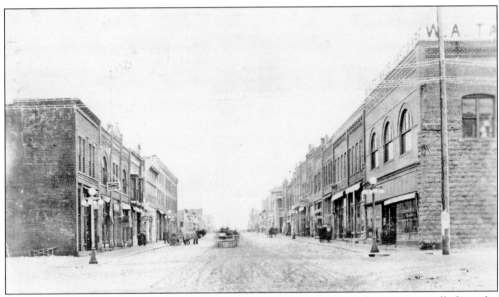

Another shot of the same block dates from after 1912, when streetlights were installed on the sidewalks. (Note, however, the horses on the left-hand side of the street.) This picture also provides a good view of the William A. Talmadge Hardware Building in the right foreground. Known as "Sycamore Bill," the Kentucky-born Talmadge was also the first elected treasurer of Carbon County. This building operated as a hardware store until the 1990s.

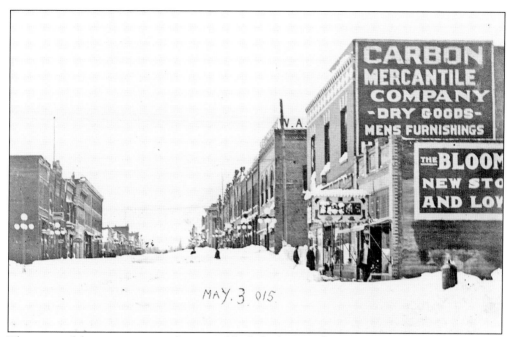

This view of downtown comes from one block further north, at Ninth Street. The Talmadge building is in the middle right. On the right, the Carbon Mercantile Company was established in 1895, specializing in clothing, gloves, shoes, and corsets.

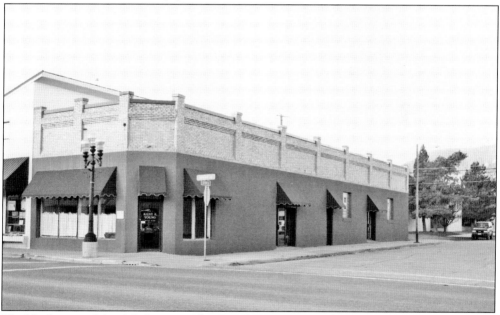

The Niethammer Meat Market opened at Broadway Avenue and Thirteenth Street in 1916 with the most advanced equipment available at the time. The front, with its canted corner entrance, was a brightly lit retail shop. The middle portion was a huge walk-in refrigerator, and the back had a kitchen where employees made mincemeat, sausage, wieners, and head cheese. The basement had a smoke room to cure bacon, hams, and sausage. This 2007 photograph shows its current use as offices. (Author's collection.)

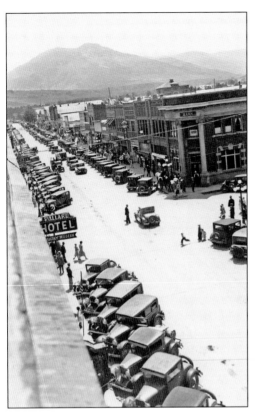

The uniformity of vehicles from the 1920s presents a wonderful symmetry to this view from atop the Pollard Hotel, probably on the Fourth of July. The contrast of compact city and distant mountain vistas has always been pleasing to the eye.

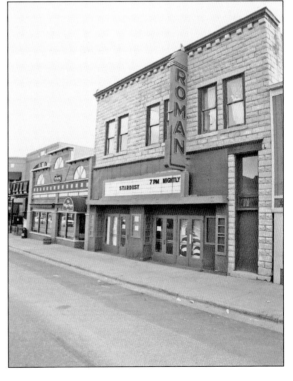

Steve Roman, Red Lodge's "movie man," already owned two theaters when he opened the Roman Theater in 1917. Four of his children accompanied movies on the Wurlitzer, violin, piano, and drums, while a fifth served as projectionist and mom ran the rooming house upstairs. The facade was remodeled in 1935 in a Hollywood moderne style, including air-conditioning, Formica panels, and art deco styling. This photograph dates from 2007. (Author's collection.)

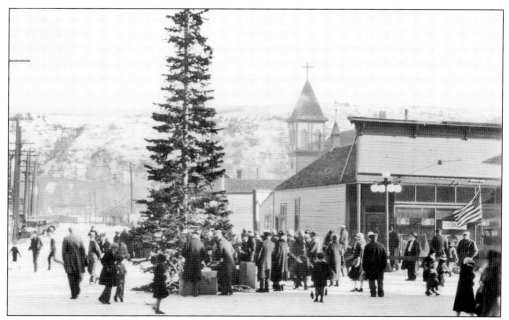

Downtown has always been a popular place for Red Lodge folks to celebrate Christmas. Here people gather around a tree placed in the center of the intersection of Broadway Avenue and Eleventh Street in the 1920s. The church in the background is the Finnish Evangelical Lutheran Church, which was located behind city hall. It was burned by an arsonist in 1972.

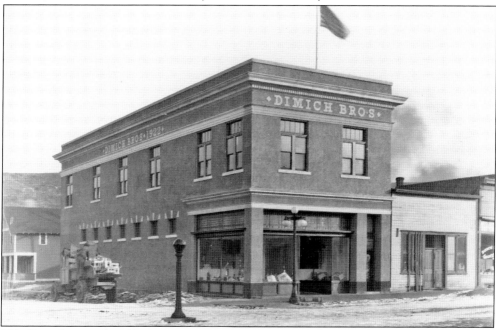

Mike Dimich opened a self-service grocery store at the corner of Broadway Avenue and Thirteenth Street in 1922. One of Dimich's sons recalled ruefully that the grocery was ahead of its time: customers were used to storekeepers who followed them around the store, writing up an order for delivery. Although the building burned in 1982, the picture's background shows the existing Old Kentucky Home at left and Blue Ribbon Bar at right.

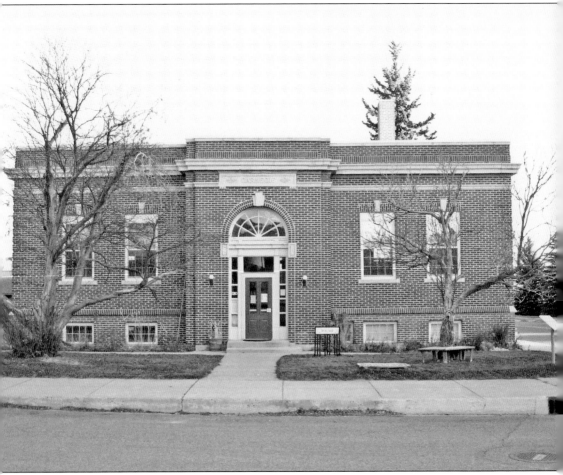

The Red Lodge Carnegie Library, at the corner of Eighth Street and Broadway Avenue, was constructed in 1919 with money from industrialist Andrew Carnegie. A Scottish immigrant who credited books for providing working boys such as himself with the opportunity to improve themselves, Carnegie funded over 2,500 libraries worldwide, 17 in Montana. Like most, this one has a staircase to the front door, symbolic of the way a person elevates one's self upon entering. A 1993 expansion, funded by the estate of Red Lodge residents Mary and Herbert Koski, added an elevator and new back wing that nearly doubled the size of the building. Mary Adams (wife of Dr. Edwin Adams) served as librarian from 1925 until her death in 1965, when she was replaced by her adopted son Bob Moran, who served another 40 unbroken years in the post, retiring in 2005. (Author's collection.)

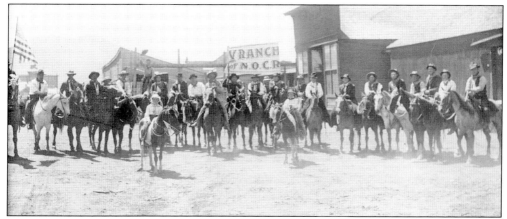

The man at the far left of these 1920s horsemen, in the white shirt on the white horse, is Dr. Carl Koehn, a Red Lodge mayor. The boy on the pony in front is his adopted son Bill Connor. Koehn's daughter, Gretchen Arndt, recalls that if anyone went up the stairs to her father's second-story office on Broadway, he or she had to be sure to turn right, because to the left was a parlor for ladies of the evening.

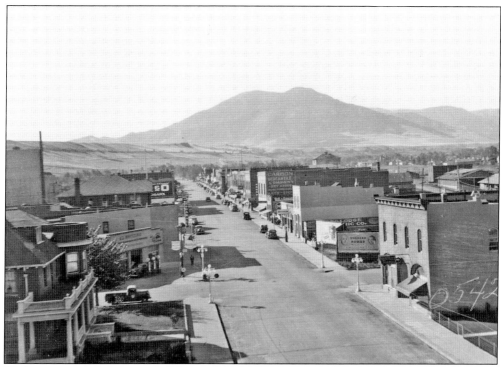

With its two-story masonry buildings marching down Broadway Avenue toward the flanks of Mount Maurice, Red Lodge's central business district has changed surprisingly little over the years. This view from the top of the Labor Temple (now the Carbon County Historical Society and Museum) around 1930 shows many buildings that still stand today.

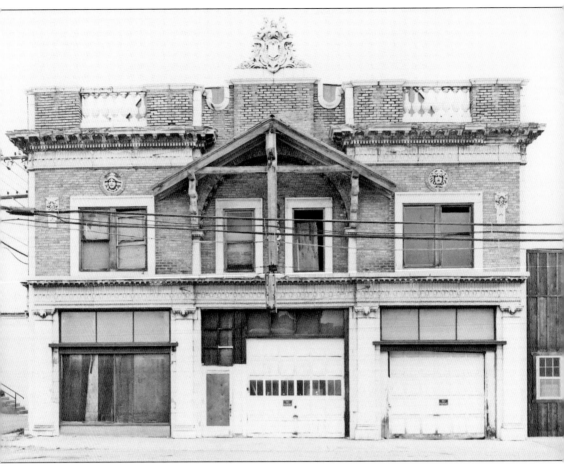

After World War I, optimism and prosperity reigned in Red Lodge, leading to the 1920 construction of the Theatorium, a grand three-story structure with a six-story rear fly loft. It cost $140,000 ($1.6 million in 2006 dollars). It had a seating capacity of 1,000 people for traveling shows, vaudeville, local productions, and Chautauqua events. There was also a dance hall in the basement. But after the West Side Mine closed in 1924, the building was used only occasionally. In the 1930s, it was converted to a distillery, and the garage bays date from its post–World War II use as an automobile body shop. The whimsical facade ornamentations, including Gorgonian figures and terra-cotta cartouches, are unmatched by any theater in the state. Though the building's interior remains gutted, these exterior features have been upgraded since the mid-1980s, when this photograph was taken.

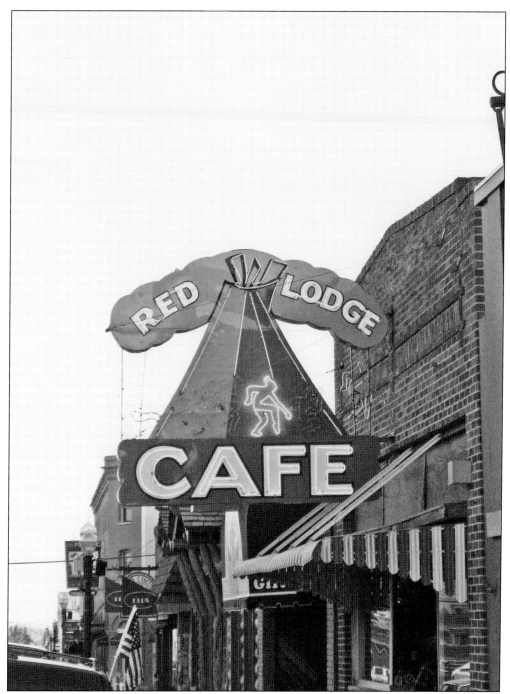

Today neon signs, such in as this 2007 shot of the Red Lodge Café, are part of the delightful historical look of Red Lodge's downtown area. However, these signs date from a very different era than the buildings they decorate. The city's first neon sign arrived in 1931 for the B. W. Holt store. The Red Lodge Café sign, with its flashing red 12-foot-high tepee and dancing natives, dates from 1948. Along with the carved totem poles and painted mountain scenes inside, the sign represents the town's increasing reliance on tourism in the post-mining era. (Author's collection.)

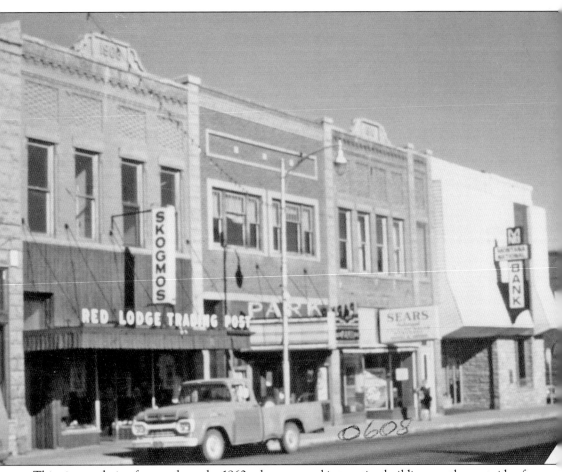

This picture, dating from perhaps the 1960s, shows several interesting buildings on the west side of Broadway Avenue near Eleventh Street. The building shown here as Skogmo's Red Lodge Trading Post was constructed as the Star Theater in 1908 and renamed the Alcazar when purchased by the Roman family in 1911, then converted to a pool hall, with the upper floor being used as a brothel called the Orpheum Rooms. Next to it is the Park Theater, which was built as the Iris Theater in 1925. The Park Theater marquee was added in the 1940s. At the far right is the old Meyer and Chapman Bank building, its second story covered in metal sheeting. This building burned in the 1980s. This picture is also notable for showing a portion of the Tunnel of Lights, a longtime downtown phenomenon in which strings of lights ran diagonally across Broadway, strung between telephone poles through the downtown district. The Tunnel of Lights was discontinued when vintage streetlights were installed in 2006.

Four

NEIGHBORHOODS

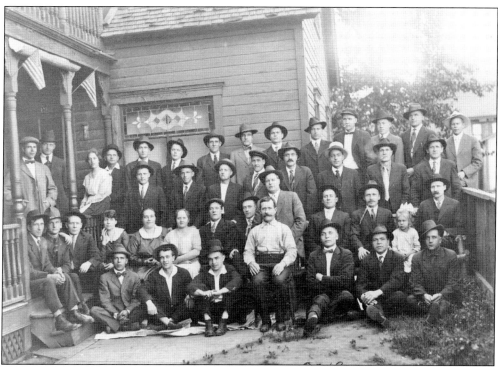

The growing mines attracted immigrants from all over Europe who settled in distinct neighborhoods with their peers. This chapter explores life in those neighborhoods. Many mine workers were bachelors or were saving money to bring their families from the old country and so lived in boardinghouses. Sometimes miners even shared a bed with a man who worked a different shift. Here the mostly Finnish boarders of the Suomela boardinghouse gather in their Sunday best for a photograph, believed to have been taken in 1918.

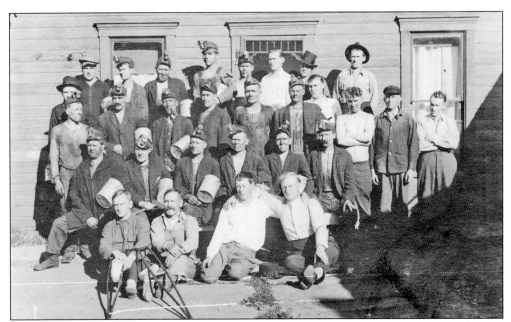

Here some Suomela boarders gather again, this time in the back of the house near the washroom. One large washroom often served two adjoining boardinghouses. They served a vital purpose, especially in early years when sooty miners would return from work and splash away coal dust in the tub. In later years, the mines installed their own washrooms, and miners no longer had to trek home in sooty wet diggers.

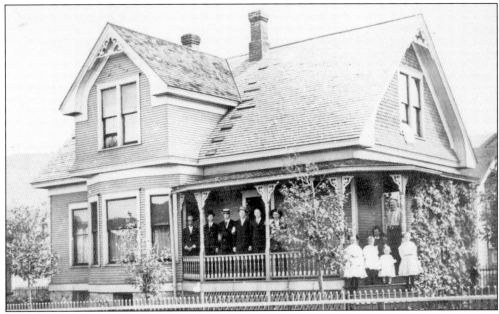

This undated photograph shows the Alex Karvonen boardinghouse at 2 South Platt Avenue, one block east of the Pollard. In addition to lowering the cost of living for miners, boardinghouses provided employment for immigrant women, who cooked, washed, cleaned, and served meals to the residents. This was the Finn Town neighborhood, which in addition to residences featured a few commercial establishments.

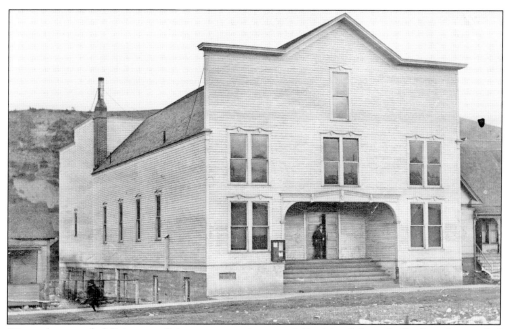

Given the crowded living conditions, many miners socialized in clubs or halls that also tended to segregate by ethnicity. The picture above shows the Finn Workers Hall, constructed in 1912 on Platt Avenue between Thirteenth and Fourteenth Streets. The picture below shows workers posing for the camera during construction. A community effort, the Finns used *talkoo* ("building bee") to put up the structure. Red Lodge Finns were not only community minded but highly literate. The opera house had a library of works in Finnish, and the Red Lodge *Picket* newspaper, the primary source of news in the historic period, printed supplemental pages in Finnish during the 1910s. The Workers Hall building was burned by an arsonist, the same one who torched the church two blocks away, in the 1970s.

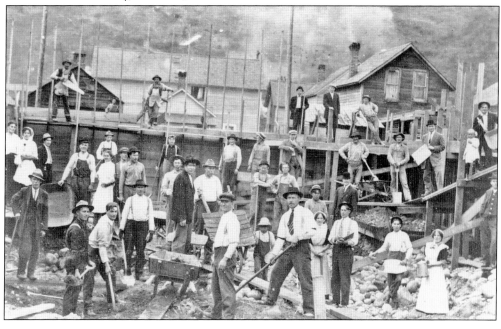

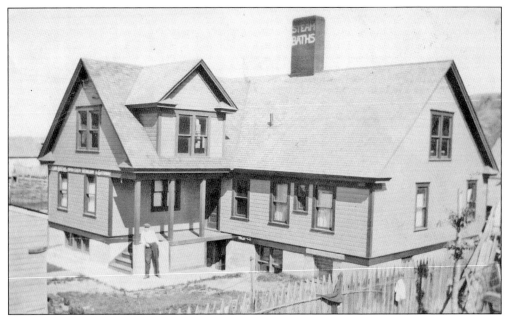

Finns brought to the new country the tradition of the sauna. Four commercial saunas operated in Red Lodge, typically open on Wednesdays and Saturdays so patrons could scrub down twice a week. Pictured here is the Honkala sauna at the back of the lot at Tenth Street and Platt Avenue. It had separate accommodations for men and women as well as private rooms. Though the sauna building later burned, the Honkala family home still stands in front of it.

Italians settled in Little Italy, north of Finn Town near the brewery building, and also near the entrance to the West Side Mine at Fourteenth Street. This undated picture shows a group of Italians in the latter area (note the smokestacks in the background to the left). In the right background is a set of pigeon roosts. Pigeons served with polenta were a neighborhood delicacy.

Another immigrant neighborhood, at Broadway Avenue and Seventeenth Street in a forested area later occupied by the Roosevelt School, was Davisville. Bobby and Mammy Davis constructed these crude cabins, which they rented to immigrant miners, mostly Austrians, Croatians, and Serbians. Loren Newman recalled that because the place was always a mess, when the shacks burned in a fire shortly after World War I, "The fire department was not too anxious to put the fire out."

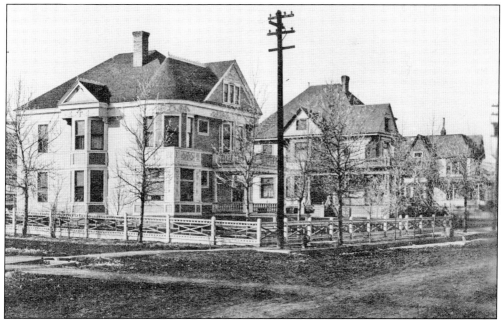

Though most neighborhoods had ethnic names, more mysterious is the origin of the name Hi-Bug, the neighborhood north of Eighth Street that housed the mostly U.S.-born Anglo-Americans. Shown here are the Meyer, Chapman, and O'Shea residences in the heart of Hi-Bug.

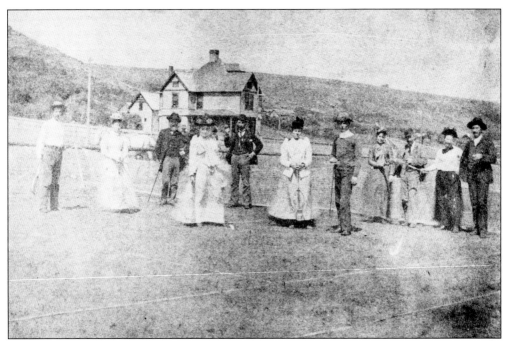

The picture above, from 1891, shows that the residence of Dr. J. Maurice Fox was the first to be constructed in Hi-Bug. The home had grass tennis courts on its manicured lawn, and the people here are gathered for a tennis match. Fox, a Kentucky native and former Confederate soldier, was the first superintendent of the Rocky Fork coal mine. In 1901, his daughters and some friends climbed the mountain lying directly south of Red Lodge. When they got to the top they broke a bottle of champagne and christened it Mount Maurice in his honor. The house itself was demolished in 1946. By 1908, as the picture below shows, the Hi-Bug neighborhood was fully developed, though its curbside trees were still a ways from maturity. Many of these stately homes are well preserved today.

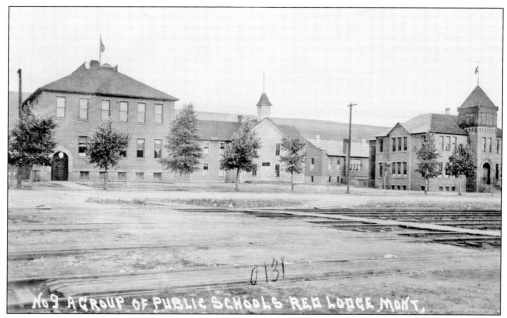

City schools were located on Villard Avenue between Ninth and Tenth Streets (the block is now a city park housing tennis courts). In the photograph above, the building at left is the Field School, named after children's poet Eugene Field and in use from 1908 to 1952. Next is the wood-frame Central School, built in 1891. In a separate building behind the telephone pole is the manual arts building, an industrial shop for junior-high children. At right is Washington Hall, the city's original high school, constructed in 1905. After 1913, it served elementary grades, and after 1933 it was a gymnasium. It was torn down in 1952. The photograph below shows the Lincoln School, constructed in 1910 to serve children in the southern portion of the city. It was located at 723 South Adams Avenue, where the Messiah Lutheran Church now stands.

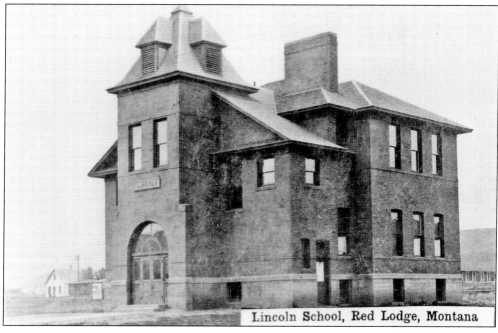

Lincoln School, Red Lodge, Montana

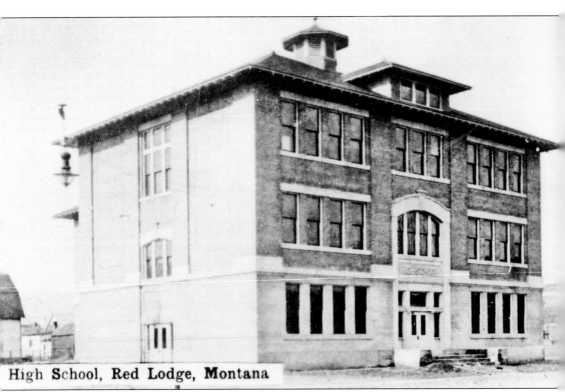

High School, Red Lodge, Montana

Carbon County High School was completed in 1913 on Fourteenth Street at the site of the current swimming pool. Local builder Antone Roat constructed it for $27,000 ($540,000 in 2006 dollars). This picture dates from before 1920, when a first-floor addition called "the sheepshed" was completed on the left side of the building. The student body peaked in the early 1930s at nearly 300 students from all over Carbon County. Through the 1940s, other communities in the county built their own high schools, and in 1951, this building became the Red Lodge High School. When a new school was built in 1961, this building was abandoned and later razed.

Though men worked the mines, women were also a vibrant part of Red Lodge history. For example, Finns formed an all-women band, shown here in 1907. The only male was the conductor, Oscar Snojanen, shown at center. Music formed the center of the social lives of many different Red Lodge ethnicities, and Red Lodge orchestras often traveled to perform in other area towns.

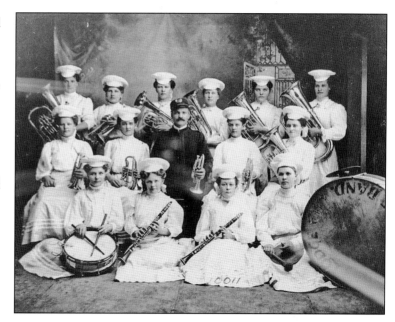

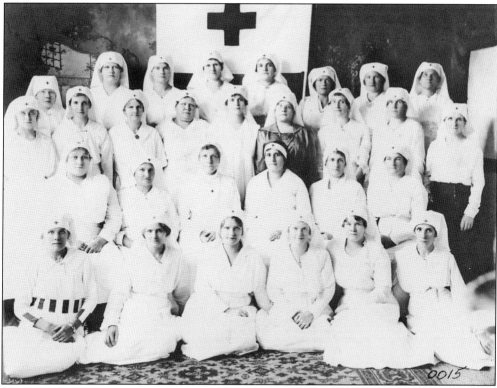

World War I was an especially difficult time for immigrants in Red Lodge. While wars and socialist movements wracked Europe, unpleasantries also occasionally reached across the Atlantic. Many immigrants were socialists, and others opposed the war. However, many Red Lodge residents supported the war effort in their adopted country, as seen with these Finnish-American Red Cross workers gathered in uniform for a photograph.

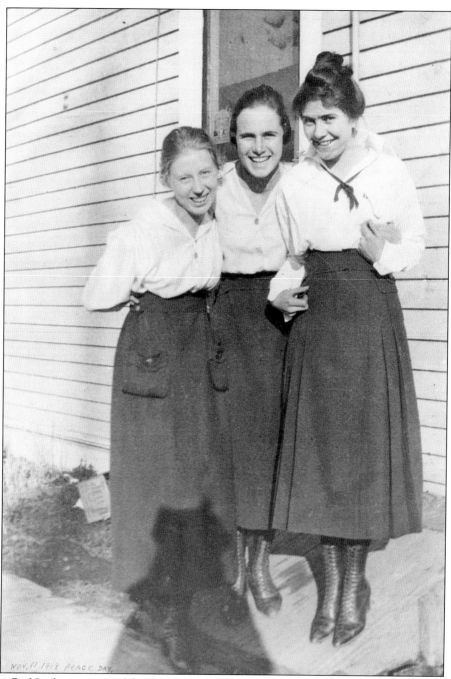

NOV. 11 1918 PEACE DAY,

Young Red Lodge women celebrated "Peace Day" (Armistice Day) on November 11, 1918, the end of World War I. At left, Inez Abrahamson was a stenographer at the Red Lodge Abstract and Title Company. At center, Clara Becklen worked in the county clerk's office. The following year, she would marry Henry "Ted" Greene, and in 1926, they moved to Detroit, Michigan, where she worked at Chrysler. When the Greenes retired in 1961, they returned to Roberts, and Clara came within 10 days of living to 100 years old. At right, Louise Pollard was the daughter of hotelier Thomas Pollard. She later married D. W. Sanford and moved to Freeland, Michigan.

The end of the war was not a uniformly happy time. Like many other communities, Red Lodge suffered from the influenza outbreaks of 1918. Among the deceased was Sadie Collins Hakala. Her funeral, shown here in the Finnish Workers Hall, was typical of these types of ceremonies at that time.

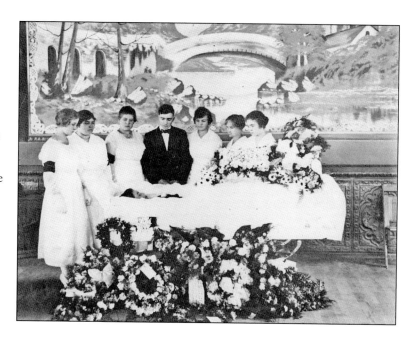

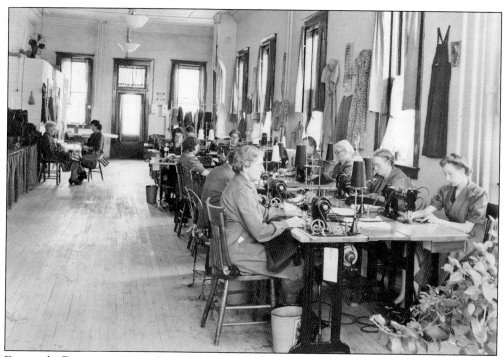

During the Depression, women's gatherings took on a more work-like tone. Here Red Lodge women are gathered in the Works Progress Administration Sewing Room around 1938. Women were taught to coordinate their skill with others and to utilize their time and effort to the greatest advantage. The clothing and blankets they sewed were distributed to hospitals and orphanages.

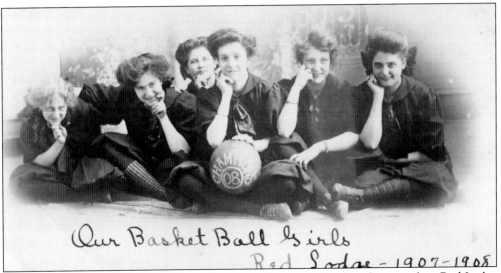

Our Basket Ball Girls
Red Lodge — 1907–1908

Red Lodge's younger residents often gathered to play sports. In this photograph, a Red Lodge girls' basketball team poses with a ball indicating they were the 1908 champions. The first Red Lodge basketball teams, starting in 1903, were girls' teams. The boys did not have a school team until 1908.

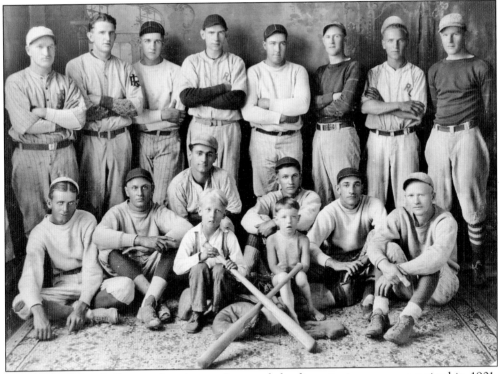

Among men, baseball was a favorite pastime, and the first city team was organized in 1901. In the 1920s, Red Lodge faced off against Bearcreek every Fourth of July in Red Lodge and Labor Day in Bearcreek. By 1930, however, when this picture was taken, the two towns had consolidated. In earliest years, immigrants played soccer, though later American football exerted its influence locally.

Five

HIGHWAY

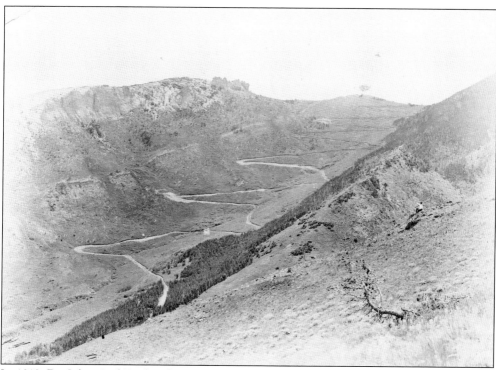

In 1919, Dr. John Carl Frederick Siegfriedt (1879–1940) first sought to build a road over the Beartooths from his then-home in Bearcreek. He called it the Black and White Trail. That summer, he built 13 switchbacks up the northeast side of Mount Maurice, as seen here. Siegfriedt intended to build his road across the Line Creek Plateau and then roughly follow the path of today's road. However, Siegfriedt was trying to finance the road by popular subscription, and he soon ran out of money.

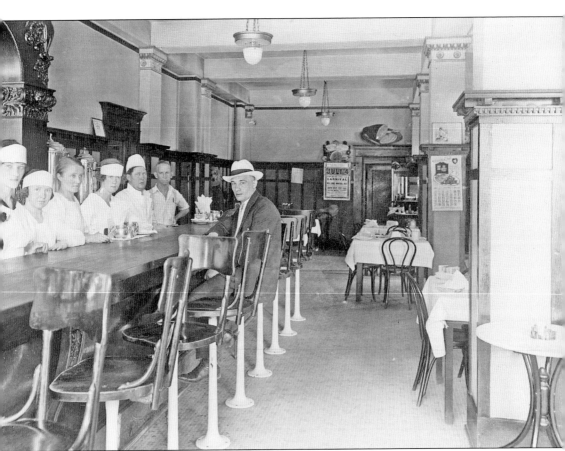

In the winter of 1924, a group met in a Red Lodge hotel and determined to get the federal government to build the road to Cooke. Their meeting place may have been here, in the Pollard Hotel cafeteria (pictured in 1922), though it was more likely in the adjacent lobby. The seven present included Siegfriedt, Red Lodge mayor Carl Koehn, hotelier Tom Pollard, and Oliver H. P. Shelley, newly arrived in town as publisher of the *Carbon County News*. Their plan faced many obstacles. As the *Billings Gazette* later wrote, "That it was a seemingly hopeless attempt from the start was apparent to everyone but the men who started it." And, the newspaper added, within a few years the hopelessness was clear to all but Siegfriedt and Shelley.

O. H. P. Shelley, pictured at right in the image to the right, made numerous trips to Washington to secure funding. A bill passed the Senate (but not the House of Representatives) in 1926. Harry Mitchell, at left, conducted the first survey of the route in 1927. His expedition would have resembled that for the Black and White Trail, pictured below. It estimated that a road to Cooke City would cost $1.14 million ($12.6 million in 2006 dollars). A road from Cooke down the Stillwater valley (to Big Timber) would have cost $985,000; down the Clark Fork (to Cody), $915,000. Montana senator Scott Leavitt included appropriation for the Mitchell route in a bill to provide approach roads to national parks throughout the country. When Pres. Herbert Hoover signed the bill in January 1931, "The announcement touched off the greatest celebration this mining town has ever known," wrote the *Billings Gazette*.

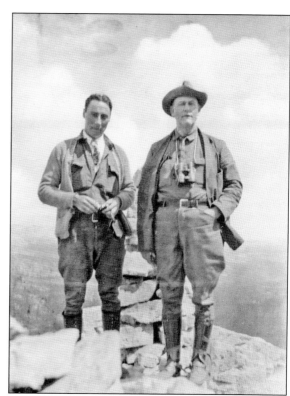

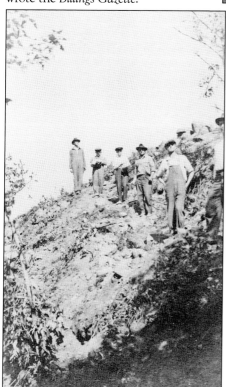

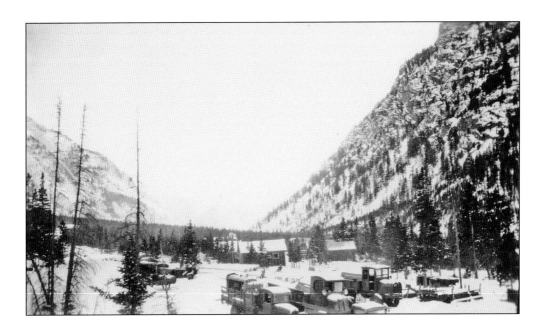

Morrison-Knudsen (M-K), a small company based in Idaho, won the contract to build the switchbacks: almost 12 miles ending at Twin Lakes. M-K built a highway camp of cabins and temporary shelters to house up to 175 of its workers at an old Forest Service pack station known as the Tin Can Camp at the bottom of the switchbacks, as shown above. The M-K camp had electricity, as shown below. It also had street lamps and a water system. The men worked seven days a week all summer long. John Yurkovich recalled that despite the grueling work schedule, some men would hike 16 miles into Red Lodge for a dance, returning by dawn the next day. Though the cabins were later carted away, the site is still managed by the Forest Service as the M-K Campground.

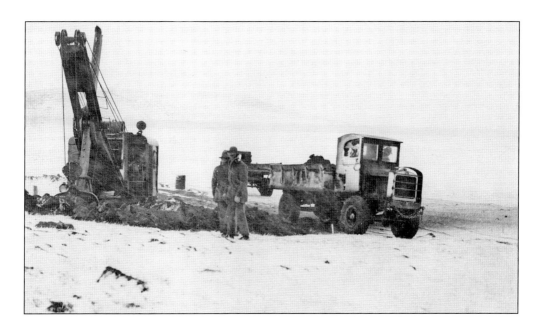

M-K brought a steam shovel from Dunraven Pass in Yellowstone via train to Red Lodge and up the canyon. In these pictures the shovel is shown at work digging the roadway. In addition to the shovel, workers used a great deal of dynamite, which could be dangerous in electrical storms. On one occasion lightning set off the charges in 60 holes, but the area had been evacuated, so nobody was injured. On another occasion, Glen Welch was killed by an accidental power explosion. Welch and Waino Timonen (caught in the drive belt of a rock crusher) were the only two casualties in the three-year construction effort. Among the men standing at the front of the picture below, O. H. P. Shelley is second from right and Dr. J. C. F. Siegfriedt is third from right.

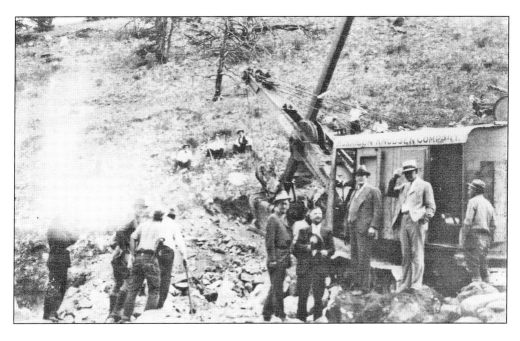

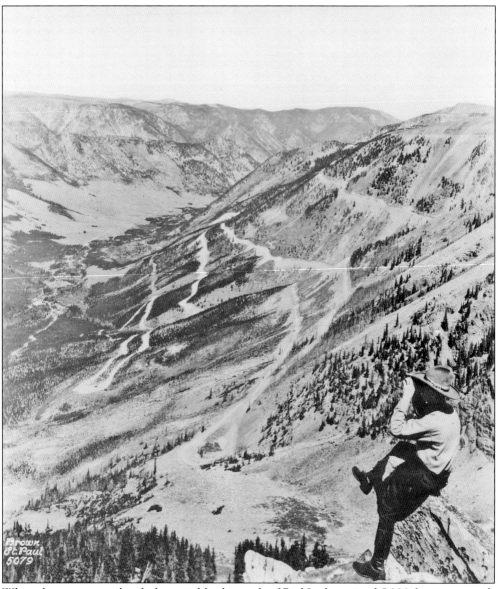

When they were completed, the switchbacks south of Red Lodge gained 5,000 feet in a stretch of 15 miles. An account of its opening noted that the road covered 19 switchbacks and 82 "full curves" between Red Lodge and Long Lake. In an article published in August 1935, the summer before the road officially opened, the *Billings Gazette* wrote, "Folks who are unused to mountain driving get that hair-raising feeling along the spine when the start up or down the Rock Creek switchbacks. But after the first few turns and a switchback or two they forget their fears and give themselves up to the scenic delights unfolded at every turn." At one time, the switchbacks were named, from bottom to top, Primal, Big Full Turn, Deadwood, Wyoming Rock Turn, Mae West Curve, and Frozen Man's Curve.

This picture of the switchbacks dates from the earliest years of the road, because it is not yet paved. Though initial construction had cost $1.25 million, oiling and surfacing were later budgeted at an equal amount.

One of the most heavily promoted features of the new road was the Mae West Curve, named after the buxom movie star. Surprisingly, however, through the 20th century the Red Lodge–Cooke City High Road, also known as the Beartooth Highway or simply U.S. 212, never had an official name. A 1960 movement to name it the Alpine Highway garnered little enthusiasm. In 2002, with federal designation as a National Scenic Byway, it became officially known as the Beartooth All-American Road.

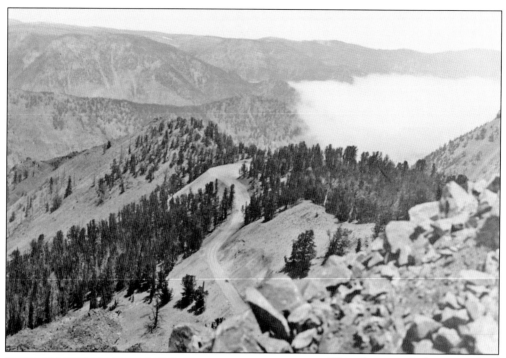

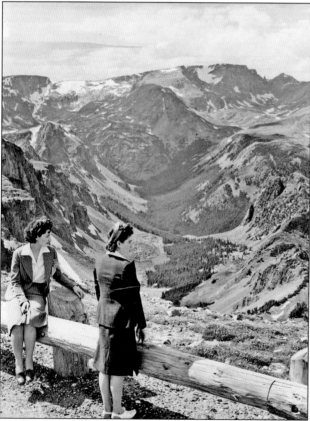

This photograph shows another view of the Mae West Curve. There have been few significant reconstruction projects on the highway since it was originally built. In the late 1960s and early 1970s, two projects engaged in widening and paving the road and replacing guardrails. A full reconstruction project was begun in the late 1990s but as of 2007 is still several years (and millions of dollars) away from completion.

Two young ladies look over the upper Rock Creek valley from the switchbacks. Not far from here, on May 20, 2005, nine inches of rain fell on the switchbacks, triggering a series of mud slides that swept away several sections of the highway, just a week before its scheduled opening. Repairs, estimated at $15-20 million, required crews to work 24 hours a day, six days a week, to reopen the road for the following summer.

Promoters referred to this view of upper Rock Creek Canyon, seen from the highway, as "Devil's Gorge." When the road was first completed, one of its unusual features was the intention to curtail gas stations, hot-dog stands, summer homes, and hotels. Additionally, no side roads were planned, so that the country could retain its primitive character. At the time, the Forest Service often used the word "primitive" to describe qualities today known as "wilderness."

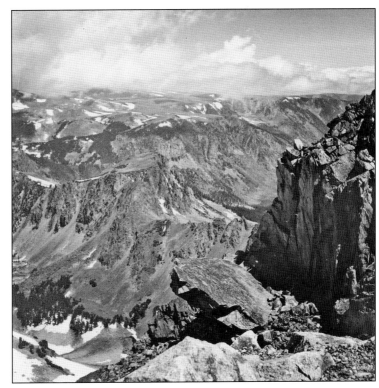

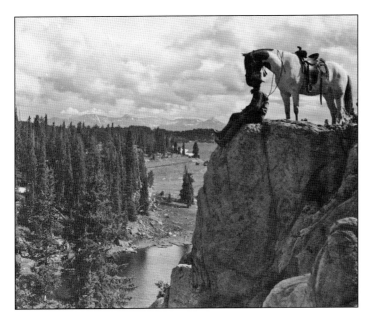

One of the biggest promoters of the new highway was the Northern Pacific Railroad (NP). To encourage tourists to take a train to Billings and a bus over the new road to Yellowstone, NP produced a series of photographs highlighting the area's scenic beauty. In this gorgeous and iconic shot, a cowboy and horse sit atop a promontory near Long Lake, with the Absaroka mountain range in the background.

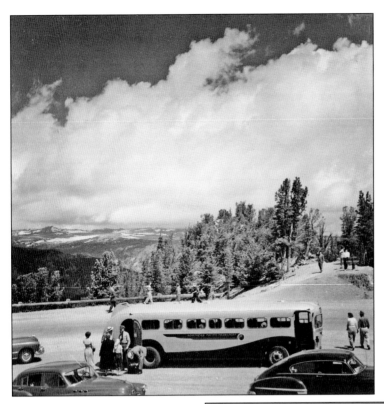

The NP ran a Yellowstone Bus to transport passengers from the Billings train station to Cooke City via the newly opened Beartooth Highway. Here the bus is pictured at Vista Point with its view down the Rock Creek valley toward Red Lodge. The Hellroaring Plateau is in the background.

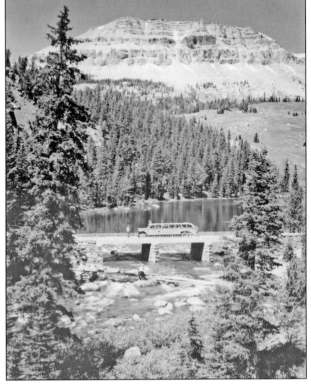

NP's Yellowstone Bus is stopped here at Beartooth Lake underneath Beartooth Butte. Note the promontory a little to the right of the butte's halfway point—from some angles, the top of that point juts up like a giant tooth. Marketing materials of the 1930s claimed that this was the "Bear's Tooth" that gave rise to the name of the mountain range.

One of the great thrills for tourists arriving on the Beartooth Highway in early summer was (and today remains) the chance to drive through huge snowdrifts. Here people stand in a Yellowstone Park convertible bus to get a better view. Note the proliferation of hats and jackets—it's none too warm up there.

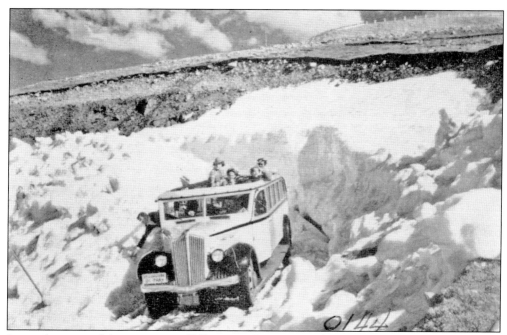

In another view of the picturesque Yellowstone Bus passing through a snowdrift, the drifts piled up in certain locations on the road can be seen. Despite 10-foot-high drifts here, the switchbacks in the upper right of the picture are clear. In the late 1930s, it typically took until mid-June for crews to clear the road of snow.

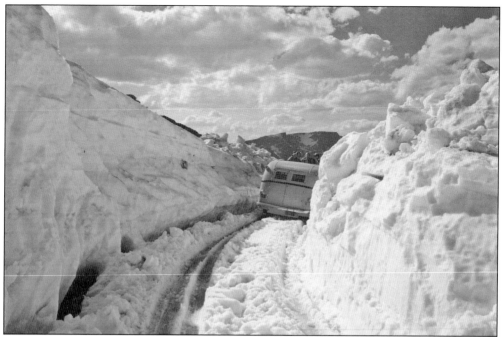

In a final image of traffic passing through snowdrifts high on the Beartooth Highway—this one taken on June 22, 1937—several inches of snow remain on the incredibly narrow roadway. At this elevation, snowstorms are quite common in June, adding to the difficulty of keeping the road open. The narrow road has no shoulders, leaving little room to store snow.

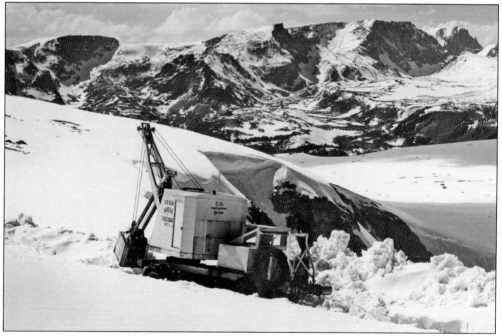

In the 1930s, much of the road-clearing was performed by steam shovel, as seen in this 1937 shot taken above Twin Lakes. At the time, the Beartooths were often known as the "Land of the Shining Mountains," and the background here suggests why.

The shovel belonged to the Federal Bureau of Public Roads, which used Park Service money to maintain the road. After 1945, Park Service crews performed the maintenance but often used Forest Service funds. With no clear funding source delineated by law, maintenance of the highway has always been a contentious issue, and thus the road is sometimes known as "an orphaned highway."

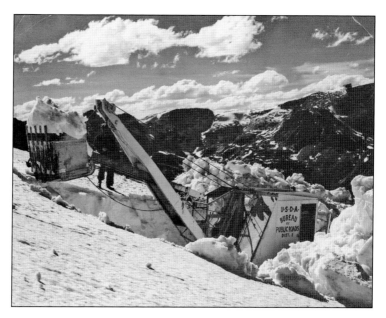

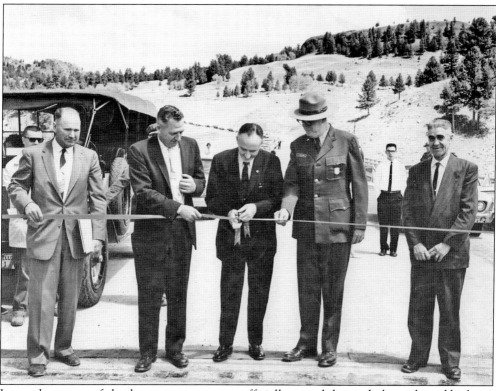

In part because no federal or state agency ever officially owned the road, the orphaned highway was a continuous political football and its spring opening a grand ceremony. This picture, taken in the early 1960s, shows Montana senator Mike Mansfield cutting the ribbon, accompanied at far left by Ralph Thomas of Red Lodge and at far right by Red Lodge mayor D. W. Columbus, with Park Service personnel between them.

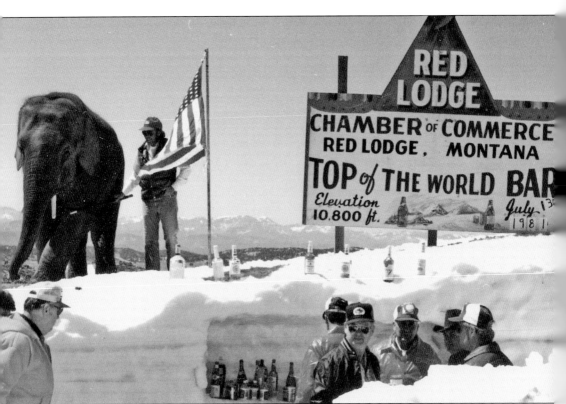

Annually beginning in 1948, the Top of the World Bar was carved out of snow on the pass. "Our special drink," Pius Meier later recalled for the *Local Rag*, "was Mountain Dew with a double-shot of vodka. I tell you, you get people 70–80 years old and you give them a shot of that—oh boy! Everybody starts dancing!" Starting in the 1960s, the one-day event would also include local can-can dancers, Festival of Nations flags, and other attractions. This 1981 photograph shows the bar carved out of snow, the chamber of commerce sign, and, in the upper left, a pink-tinted elephant. Upon request, the elephant could stand on its hind legs, sit on the bar, and hold a Mountain Dew with its trunk. The Top of the World Bar tradition ended in the late 1980s. (Courtesy Ernie Strum.)

Six

RANCH

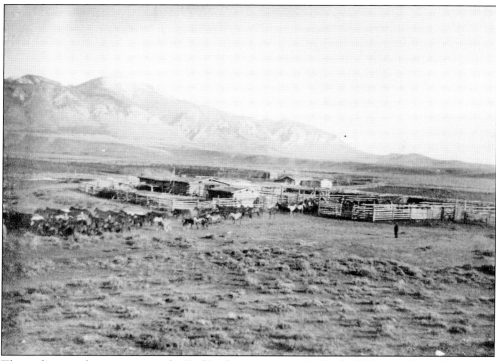

The earliest cattle enterprise in the Red Lodge area was probably the Dilworth Cattle Company. Established in 1882 southeast of Mount Maurice, it is shown here in 1895. Dilworth cattle ranged from the upper Stillwater valley (the present town of Nye) to the confluence of the Bighorn and Yellowstone Rivers. Nelson Story of Bozeman and other large cattle operators also ran herds in this area, which was then part of Gallatin County and the Crow reservation. Other settlers joined them after Crow lands were thrown open to homesteading in 1892.

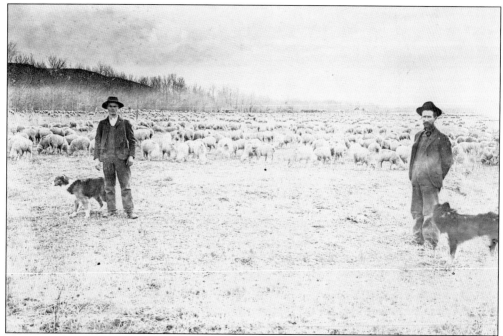

Sheep ranching also played a role in area agriculture. In 1893, the *Red Lodge Picket* reported over 25,000 sheep ranging near the headwaters of Red Lodge Creek. In 1899, one million pounds of wool were shipped out of Carbon County. Until 1960, sheep commonly grazed the high plateaus of the Beartooths. This photograph shows Jake Handeland and Pete Rogness on the Stillwater River in the early 1920s.

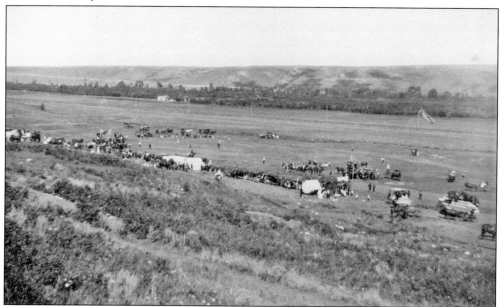

One of the biggest events of the year was the county fair, held where today's golf course meets Highway 212. This picture shows the fairgrounds in 1896. The fair was attended predominantly by ranchers from as far as Joliet, Absarokee, and Fishtail rather than the miners of Red Lodge. Races—on foot, pony, horse, and bicycle—were a big attraction of the fair.

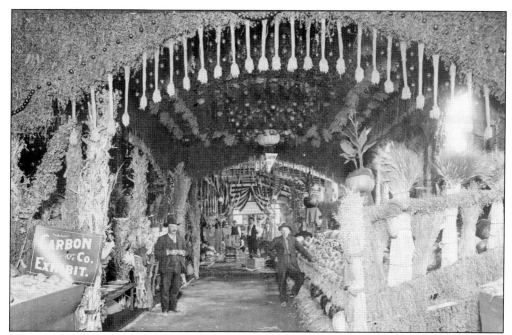

The fruit exhibit, shown here in 1906, was a popular feature of the fair's exhibit hall. Fruit on display included numerous varieties of apples and crab apples, plums, cherries, watermelons, and a lemon-like fruit called citron. A nearby vegetable exhibit showed over three dozen varieties of vegetables. Smaller exhibits showed stock and poultry.

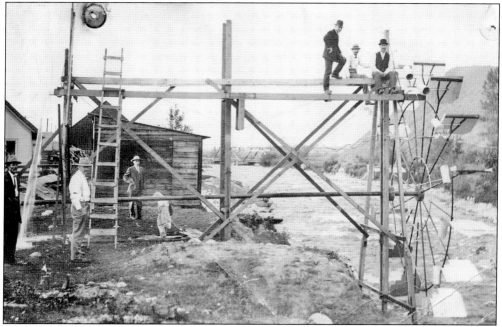

In such a dry climate, irrigation was essential to farming or gardening. This picture shows the construction of an irrigation system at the foot of Twelfth Street in Red Lodge around 1906. At the right in the photograph, a wheel picks up water from Rock Creek. Three men sit atop a scaffold, ready to set pipes that will take the water to its destination.

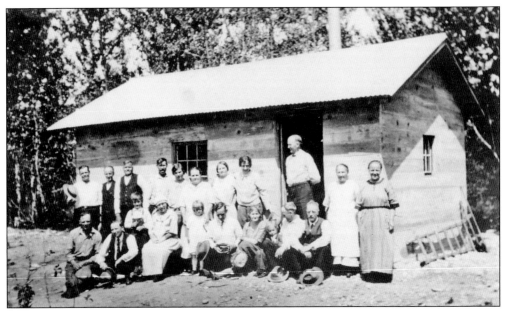

Some immigrants who originally came to work in the Red Lodge mines later took up area homesteads while retaining their strong ethnic affiliation. For example, in 1924, members of a Finnish society called the Knights and Ladies of Kaleva pose in front of a sauna they have constructed about 8 miles north of Red Lodge. Other ethnic groups—especially Norwegians, Swedes, and Danes—migrated directly to dryland farms north and west of town.

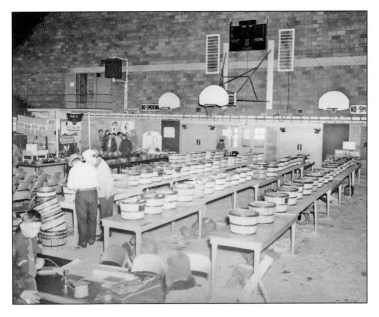

The 1950s were a difficult era for the town's economy, with the slow realization that mining would not rebound. Red Lodge tried to enhance the area's agricultural economy with events such as a Seed Show. It was held at the Workers Hall and (shown here in March 1954) at the civic center. However, given the town's elevation, it struggled in competition with emerging agricultural centers such as Billings.

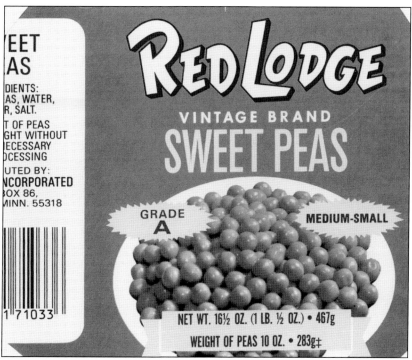

As coal production slowed, one of the biggest employers in Red Lodge, especially during the summer months, was the pea cannery in the former brewery building. The cannery opened in 1926 with M. H. Mann as manager. When he died suddenly in 1947, his son Blaine Mann took over. Red Lodge Peas were marketed throughout the region as "The Peas that Please!" A truck collected vines from the field, and below John Collins tosses them into the "viner," which would de-vine and shell the peas. Locally owned until 1960, when it merged with a Minnesota firm, the Red Lodge cannery peaked in 1963 with 263,000 cases of peas produced. This was approximately one percent of the national production—enough to serve all of Montana, Wyoming, Idaho, and much of the Dakotas. However, the thin area soils and high costs of trucking products over long distances finally caught up with the cannery. In 1926, there were 60 other canneries in Montana, Utah, Wyoming, Idaho, and Colorado; in 1975, Red Lodge was the last one to close.

Some area agriculturalists came from a more privileged background. For example, Malcolm S. Mackay, pictured here, was the son of the president of the New York Stock Exchange. Malcolm was only 19, with just an eighth-grade education, when he first came to Montana on a hunting trip. Homesteading on the Lazy E-L ranch near Roscoe, he soon immersed himself in big-game and cattle ranching. (Courtesy Lazy E-L Ranch.)

The Mackay women were also strong characters. Helen Raynor Mackay, pictured here, was a 16-year-old Roberts schoolteacher when she met Malcolm. Later, after Malcolm's father died and they returned east, she journeyed to Europe to study with Carl Jung. After Malcolm's death, Helen donated their collection of paintings by their friend Charlie Russell to the Montana Historical Society in Helena. (Courtesy Lazy E-L Ranch.)

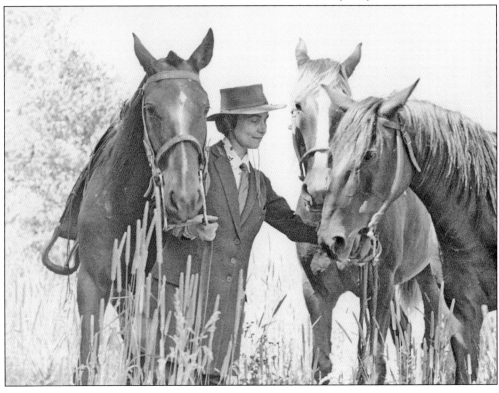

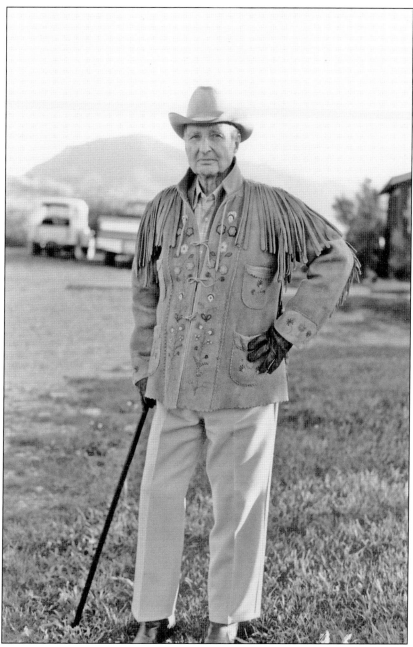

William R. Mackay Sr. (1911–1999) took over management of the Lazy E-L in 1935, shortly after the death of his father, Malcolm. He continued building up his registered Hereford bulls until 1992, the last 20 years in partnership with his son Billy. A noted Republican, Bill served as a state senator for 24 years. He served on numerous boards, including the Montana Stockgrowers Association, Montana Historical Society, National Cowboy Hall of Fame, and Rocky Mountain College, serving as president of most of them. Locally he also served on the boards of the school, rodeo, hospital, historical society, Grizzly Peak ski area, and music festival. His descendants, including granddaughter Jael Kampfe, the current Lazy E-L general manager, still play major roles on the ranch and in the community. (Courtesy Lazy E-L Ranch.)

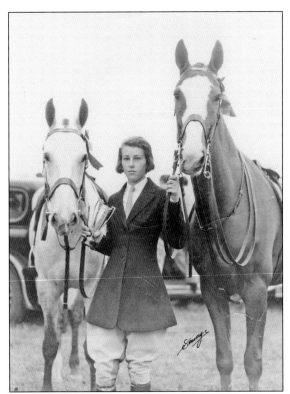

Bill's wife, Joyce C. Mackay, pictured here, was an accomplished horsewoman, showing champion stallions and geldings at the American Quarter Horse Association national competitions. Joyce was also a professional artist and a founder of the Carbon County Arts Guild and Archie Bray Foundation. (Courtesy Lazy E-L Ranch.)

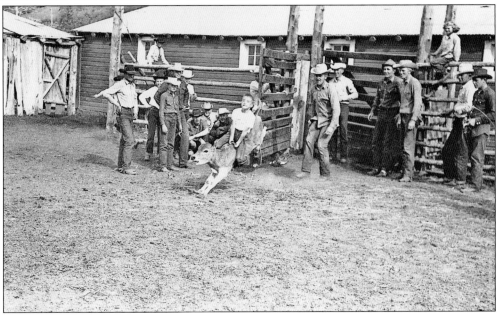

William R. "Billy" Mackay Jr., pictured here on a bucking calf in 1952, approached ranch management from a progressive viewpoint. He was a founding board member of the Northern Plains Resource Council, a nonprofit that brought together ranchers and environmentalists, and of Holistic Resource Management, an iconoclastic (though now widely accepted) method of land management. (Courtesy Lazy E-L Ranch.)

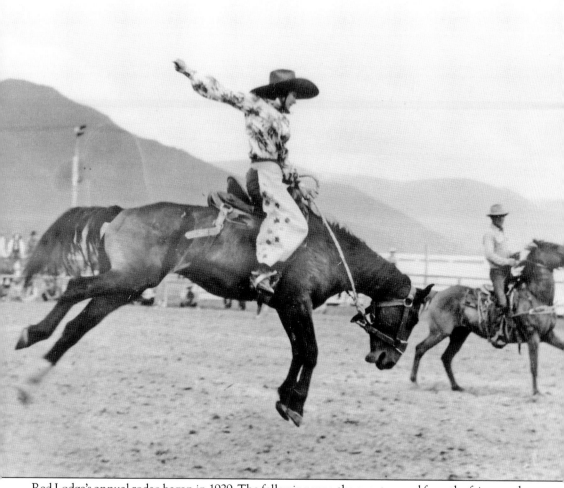

Red Lodge's annual rodeo began in 1929. The following year, the event moved from the fairgrounds to the rodeo grounds on the West Bench. In early years, the rodeo competition was combined with a parade, dances, stunt flying and parachute-jumping exhibitions, boxing exhibitions, baseball games, a carnival, and fireworks. The year 1930 featured appearances by local residents—and rising rodeo stars—Alice and Turk Greenough. In later years, they would be joined by siblings Bill and Marge to be known as the Riding Greenough family. This picture shows Alice (1902–1995), probably at a later date. In her career, Alice won saddle bronc-riding events in New York and Boston, performed before royalty in Europe, and worked as a stuntwoman on the TV series *Little House on the Prairie*. Also a stock contractor and rodeo producer, Alice was the first inductee in the Cowgirl Hall of Fame in 1975, with Marge following in 1978. Alice was also elected to the National Cowboy Hall of Fame in Oklahoma City and is listed at No. 71 among the Top 100 Most Influential Montanans.

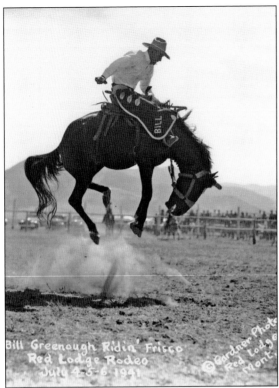

Bill Greenough Ridin' Frisco
Red Lodge Rodeo
July 4-5-6 1941

© Gardner Photo
Red Lodge
Mont.

Bill Greenough, the youngest son of Myrtle and Packsaddle Ben Greenough, was perhaps the family's most versatile rodeo competitor. He participated in saddle bronc, calf roping, and steer wrestling. However, he never rodeoed full-time, as he also worked at a large ranch on the Crow reservation. He is shown here taking first money at the 1941 Red Lodge rodeo on a horse named Frisco, on what is remembered as one of the greatest bronc rides ever seen anywhere.

Rodeo quickly grew to be one of Red Lodge's big attractions. In this 1941 picture of Bill McGuire winning the bull-riding competition on El Toro, the stands are visible in the background. The initial grandstand capacity was 1,100; new bleachers, box seats, and other improvements were added in 1941, 1968, and 1976. The renovations also improved corrals, chutes, restroom facilities, and concession stands.

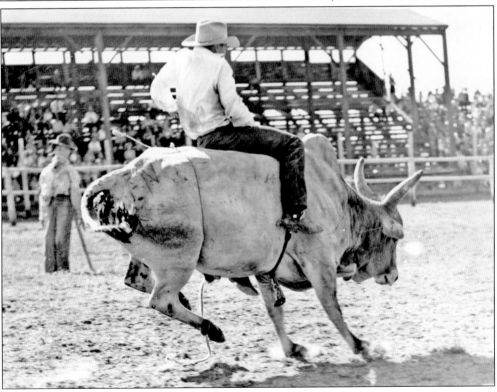

"Turk" (Thurkel Greenough, 1905–1995) was perhaps the most successful rodeo Greenough, one of the all-time great bronc riders with an easily recognizable style. He won the Pendleton Roundup in 1928; Cheyenne Frontier Days in 1933, 1935, and 1936; and the North American Championship in Calgary in 1935 and 1943. He traveled with the 101 Ranch and Cherokee Hammonds Wild West shows and also spent some time in Hollywood (see additional pictures in chapter 9). More recent Red Lodge–based rodeo stars have included John Edwards, who won the National Finals Rodeo (NFR) aggregate title in 1970; Bill Greenough's grandson Deb Greenough, the 1993 world champion bareback rider and a 13-time NFR qualifier; and Clint Branger, who came within one second of becoming the first Professional Bull Riders World Champion in 1994.

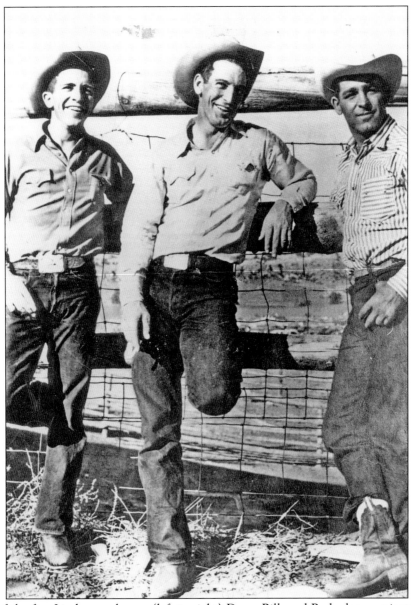

Three of the five Linderman boys—(left to right) Doug, Bill, and Bud—lean against a fence. There may never be another family where five sons are top cowboys like the Lindermans. Perhaps the most famous is Bill Linderman, arguably the greatest all-around cowboy of all-time. In 1950, Linderman accomplished something no cowboy has done since, winning world titles at both ends of the arena in steer wrestling and saddle bronc riding. He was the Professional Rodeo Cowboys Association (PRCA) bareback champion in 1943 and PRCA top all-around cowboy in 1950 and 1953. After his death in a plane crash in 1965, the PRCA announced the annual Bill Linderman trophy to recognize an outstanding career in rodeoing—an award that is still given today. The other brothers were also champions: John rode saddle broncs, George (Lup) was a bareback rider and bull rider; Bud won the PRCA bareback title in 1945; and Doug won the Red Lodge bareback championship in 1949, 1951, and 1952. Thanks to the Lindermans and the Greenoughs, the local event is officially known as the Red Lodge Home of Champions Rodeo.

Seven

FESTIVAL

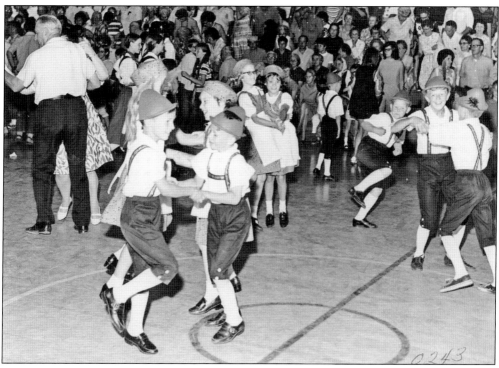

Starting in 1951, Red Lodge celebrated its multiethnic heritage with a weeklong Festival of Nations. Each of the ethnic groups that had come to Red Lodge to work the mines celebrated with music, dance, food, and crafts from the homeland. As this 1970 picture shows, the festival not only kept those traditions alive, entertaining thousands of tourists in the process, but also passed them on to the community's youth.

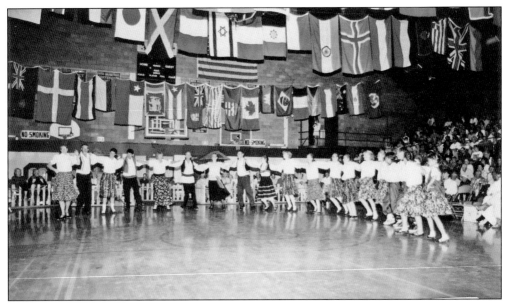

Every August, crowds filled the civic center to watch eight nightly Festival of Nations performances under flags of many nations. Each ethnic group had its own day: English/Irish/Welsh, German, Scottish, Italian, Slavic, Finnish, and Scandinavian (for Swedes, Norwegians, and Danes, since the Finns had their own night). One day was given over to new-country traditions on Montana Day, and the festival concluded with an All Nations celebration. (Courtesy Betsy Scanlin.)

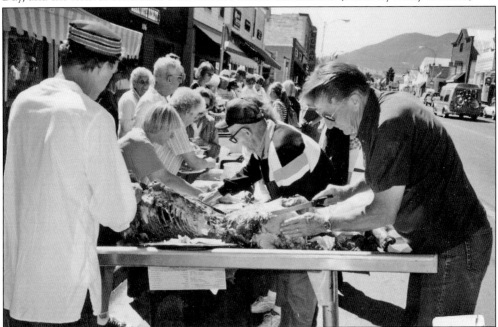

In addition to music and dancing, the festival featured ethnic food. For example, Yugoslavian Day featured a pig roast on Broadway Avenue, as shown here in 1995. Participants demonstrated how to make various traditional foods and crafts in displays throughout town. Most of the foods were given away as free samples, part of organizers' philosophy that the festival was not a moneymaking venture but rather a celebration of a unique cultural heritage. (Courtesy Betsy Scanlin.)

Librarian Bob Moran, longtime coordinator for the festival, is shown introducing longtime emcee Don Scanlin in the mid-1990s. As minister of the Congregational church in the early 1950s, Scanlin was one of the original founders of the event, along with Laura Weaver, art teacher Lucile Ralston, grocer John Lampi, and newspaper reporter Roger Davis. (Courtesy Betsy Scanlin.)

In 1982, the festival formally organized as a nonprofit, and its inaugural board gathered for this group photograph. From left to right are (first row) "Montana Vera" Buening, Nick Kosorok, and Irma Capps; (second row) Cooney Frank, Norma Schiedecker, Tom Egenes, Hazel Chamberlain, and Betsy Scanlin; (third row) Bob Moran, Irvin Amen, Dale Olson, and Tom Teini. By this time, the annual tradition had garnered Red Lodge a region-wide reputation as a multiethnic, tolerant, can-do community. (Courtesy Betsy Scanlin.)

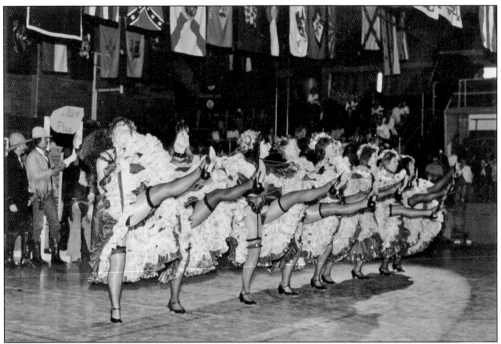

Beginning in the 1980s, a major performer on Montana Day (as well as at numerous other area events) was the Grizzly Peek-a-Boos can-can troupe. They are shown here performing at the festival in 1992. (Courtesy Betsy Scanlin.)

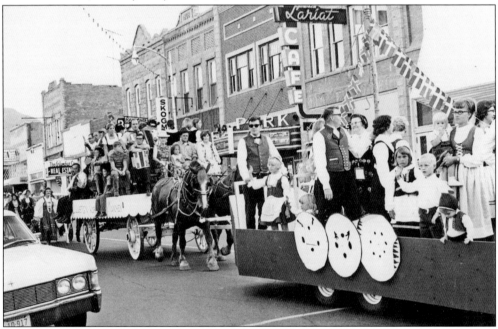

Red Lodge loves a parade, and the festival traditionally concluded with an All Nations Day parade through downtown. This picture shows the 1970 parade. In the early 21st century, after 50 years of a little-changing format, a new generation of Festival of Nations leaders restructured the event to focus on a single weekend while retaining its philosophy of celebrating ethnic diversity.

Eight

TOURISM

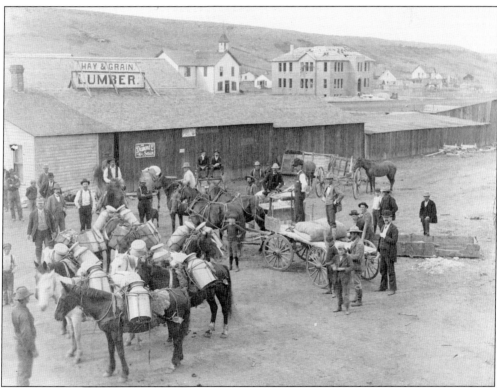

Old-time Red Lodgers stocked Beartooth lakes with trout hoping to establish self-sustaining fish populations. In this photograph from September 1899, several horses in downtown Red Lodge have been loaded with 10-gallon milk cans, each filled with 1,000 three-inch fingerling trout. In more recent years, the state has taken over fish stocking, focusing more on native species such as Yellowstone cutthroat trout rather than the eastern brook trout spread far and wide by these pioneers.

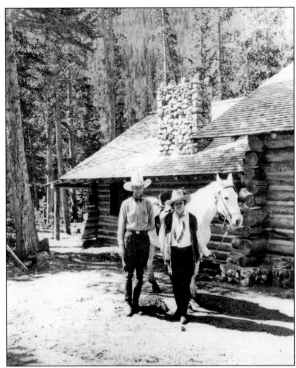

In 1917, Al Croonquist, son of a Swedish storekeeper in Red Lodge, and his wife, Senia Pollari Croonquist (shown here with their horse White Lady), began construction on Camp Senia. The first dude ranch in the Beartooths was 12 miles up the West Fork of Rock Creek. Over the next decade, it expanded to 19 log-and-stone buildings with many trails into the mountains. Al later helped organize the national Dude Ranchers Association. (Courtesy Senia Hart.)

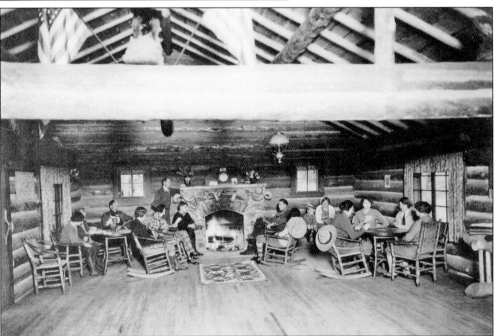

The main lodge at Camp Senia, called the "Lobby," was a central social area and reading room, as seen in the gathering here. The Lobby's construction is a well-crafted example of the Western rustic style. Though the builders were mostly Red Lodge Finns, the use of rounded rather than hewn lodgepole-pine logs was a change from typical Finn construction, which helped to emphasize the rustic, forested nature of the camp. (Courtesy Senia Hart.)

This exterior view of the Lobby shows the lodgepole forest setting of the camp between 1991 and 2007. Posed in front of it are two longtime Camp Senia employees, Matt Pollari and Celeste Roat. Celeste's son, Brian Roat, served several terms as mayor of Red Lodge. (Courtesy Senia Hart.)

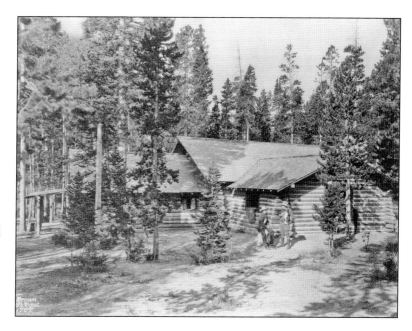

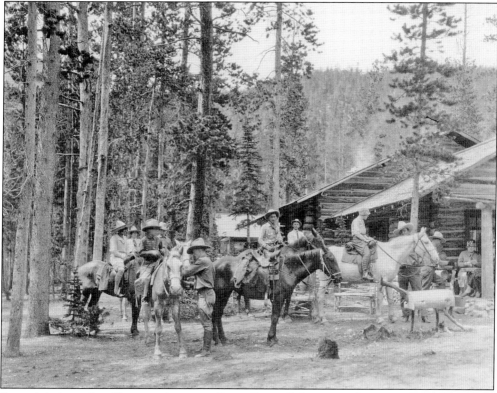

Several dudes and staff pose on horses at Camp Senia. Fishing expeditions explored Silver Run and Red Lodge Creek plateaus, as well as the West Fork valley. Up to 40 dudes at a time would stay at Camp Senia, paying $45 a week in the early 1920s (about $500 a week in 2006 dollars). Note that at least two of the gentlemen in this picture are wearing neckties. (Courtesy Senia Hart.)

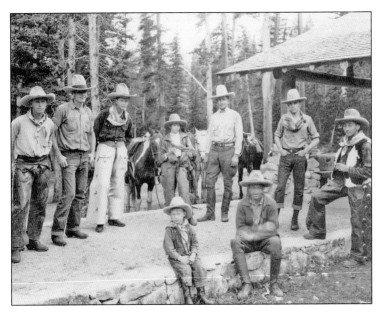

The guides of Camp Senia pose in full regalia. Al Croonquist is standing third from right. Next to him is his daughter, Senia Mabel Croonquist. Camp Senia failed in the Depression and is now a collection of privately owned summer homes. However, Senia Mabel Croonquist Hart later became a much-admired patron of arts and culture in both Billings and Red Lodge. (Courtesy Senia Hart.)

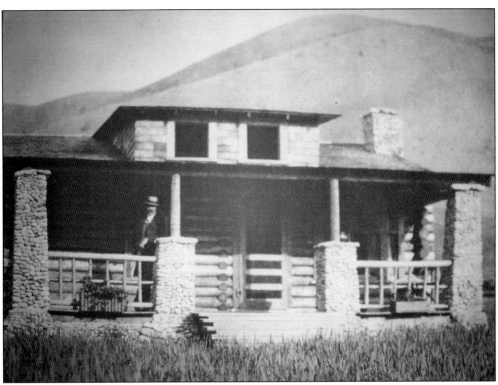

Additional development took place up the main canyon. This photograph shows the original homestead cabin at Piney Dell, about 6 miles south of Red Lodge, probably in the 1920s. The structure was eventually incorporated into Old Piney Dell restaurant. (Courtesy Rock Creek Resort.)

Dr. J. C. F. Siegfriedt built this pavilion at Piney Dell in the 1920s. The photograph above shows the exterior and the one below the interior. Siegfriedt encouraged local ethnic groups to use the pavilion as a cultural center for music and dance from the old countries. Siegfriedt was also an amateur paleontologist. In 1931, he rented some small nearby cabins and space for tents to a group of geologists from Princeton University. Their goal of the "furthering of fundamental geological science and the training of students under exceptionally favorable conditions" eventually grew into the Yellowstone Bighorn Research Association, a consortium of colleges that developed its own a summer camp at nearby Howell Gulch.

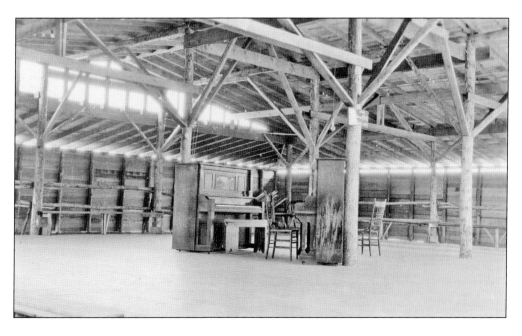

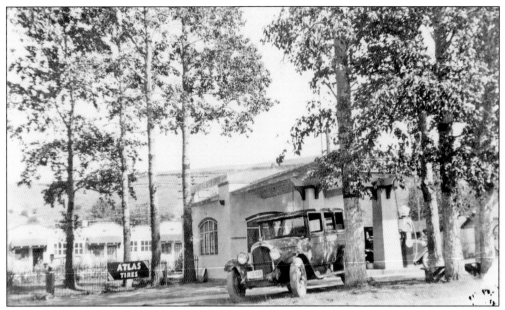

Even in the 1920s, before construction of the Beartooth Highway, Red Lodge entrepreneurs saw the possibilities for automobile tourism. This photograph shows the Calso station and Rosetto Cabins at Broadway Avenue and Seventeenth Street, which were advertised as approved by the Automobile Association of America (AAA).

Nearby, a collection of 45 tourist cabins, each one to three rooms in size, was originally called Red Lodge Court. "Native timber and stone have been used to carry out the unique, rustic design and atmosphere, yet modern conveniences have not been spared," read an advertisement for the well-landscaped, 7-acre complex centered around a fountain. Today Fountain Park's remaining cabins (some expanded) are privately owned. (Courtesy John Clayton.)

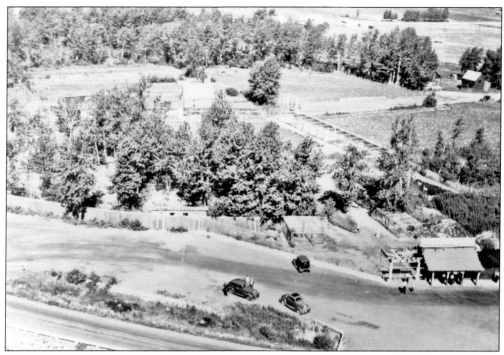

The undated aerial photograph above shows the location of the See 'Em Alive zoo at the south end of town across from the intersection of the road to Bearcreek and Belfry. The zoo was a staple of Red Lodge tourism from the 1930s into the 1970s. Visitors could see bear, deer, elk, antelope, and indeed nearly all animals native to Montana, as the photograph below shows. Les Lyons and D. W. Columbus founded the zoo as a fur farm, raising silver foxes starting in 1924. Over the next five years, they added mink, beaver, muskrat, marten, and lynx—and Red Lodge residents wanted to come see. Gradually the proprietors started charging admission, improving facilities and landscaping, and adding non-fur-bearing animals. By 1946, with the price of a silver fox pelt having dropped from $100 to $15, they stopped raising furs entirely, focusing instead on entertaining tourists.

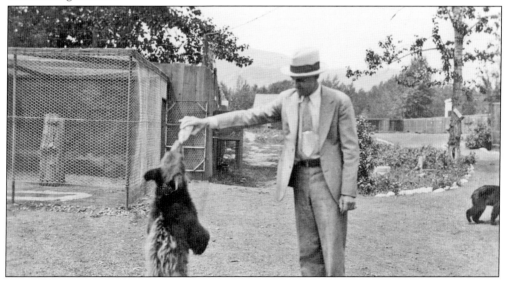

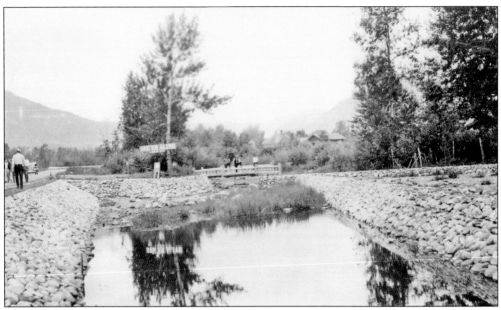

Red Lodge also had a fish hatchery just north of the zoo. In this photograph, the "See 'Em Alive" sign is just in front of the trees at middle left. The pond in the front, now filled in, was used for the hatchling trout.

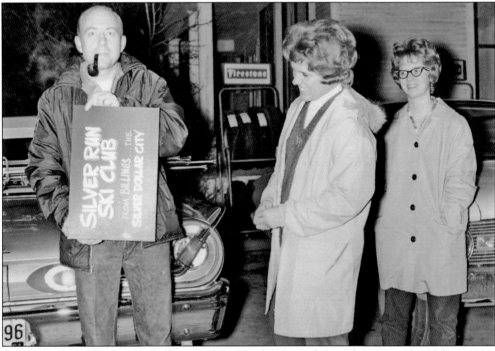

Winter sports enthusiasts in Billings and Red Lodge formed the Silver Run Ski Club in 1938. One of the oldest ski clubs in the nation, Silver Run traveled to developed ski areas, operated a rope tow hooked to an old car along Willow Creek above the Palisades Campground southwest of Red Lodge, and held fund-raisers and social activities. Here, three unidentified Silver Run members clown in the 1950s. (Courtesy Red Lodge Mountain.)

Other ski areas were attempted at Sundance on Mount Maurice and at Shangri-La up the main canyon, but they suffered from poor snow. In the photograph to the right, Kerm Carlson checks snow depths at the bottom of a preferred new site on Grizzly Peak about 1955. The site boasted a north slope, high elevations, protection from the wind, and easy access. Below, Jim May pauses to soak up some sun at the top of what is now called Miami Beach in April 1957. Grizzly Peak has an unusual spring-heavy snow pattern, and as Silver Runner Al Staley recalled in *Montana Magazine*, "We'd hike in in the spring to check the snow depths. And they were mind-boggling. Fifteen or twenty feet of snow! We didn't realize all the snow comes in the spring." (Courtesy Red Lodge Mountain.)

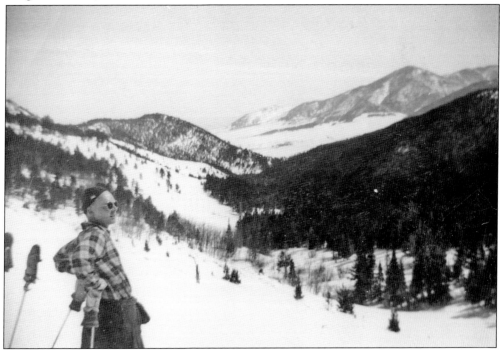

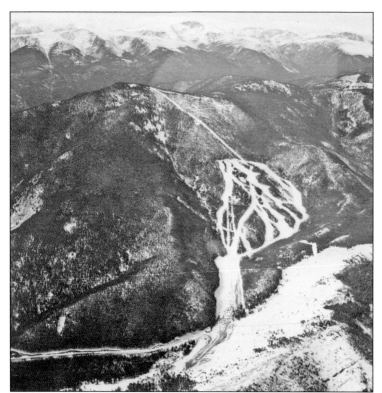

Grizzly Peak Ski Area opened in February 1960 with three runs. In this aerial view taken the following winter, a single lift runs on what is now called the Lower Mountain, ending at the base lodge in the bottom center of the photograph. However, the straight cut from the top of the runs to the top of Grizzly Peak represents the planned expansion to the Upper Mountain. (Courtesy Red Lodge Mountain.)

Howard Ellis, longtime ski area manager, is shown at the ticket office at Grizzly Peak. Note the price of lessons in the sign at the bottom: $2 apiece. In those years, however, there was no snowmaking (added in 1978 and improved regularly thereafter). By 1998, the resort, renamed Red Lodge Mountain, attracted 120,000 skier visits per year, with an estimated annual economic impact on the area economy of $5 million. (Courtesy Red Lodge Mountain.)

Curt Chase, shown under the sign in 1960, headed the resort's first ski-instruction program. Founder of the Aspen Ski Patrol, longtime director of the Aspen Ski School, and a founding director of the Professional Ski Instructors of America, Chase helped put Red Lodge skiing on the map. The bell under the Ski School sign was recycled from its previous use as the first school bell in Billings. (Courtesy Red Lodge Mountain.)

In the 1960s, Red Lodge became a favored destination for a Minneapolis women's bridge club, which is shown eating lunch in the base lodge. The Red Lodge–Minneapolis tie would grow over the years. In this picture, the woman standing at the back left is Mary Ringer, who would later move full-time to Red Lodge. Her son, Rob, now serves as ski-area manager. (Courtesy Red Lodge Mountain.)

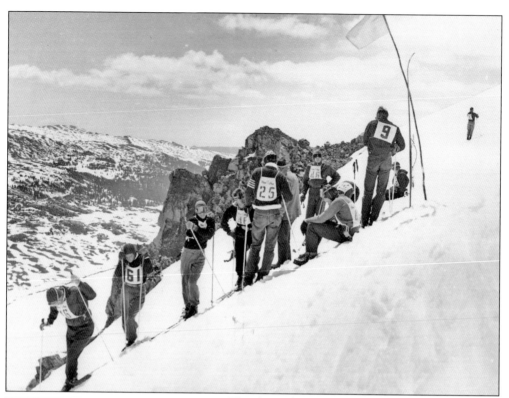

Thanks to the Beartooth Highway, area skiing extended into May, June, and even July as early as 1940. This photograph shows unidentified racers in the High Road Summer Slalom at Gardner Headwall in June 1957. At nearby Twin Lakes, Pepi Gramshammer, Anderl Molterer, and Erich Sailer established the International Summer Ski Camp in 1966, attracting up to 400 young skiers per year. (Courtesy Red Lodge Mountain.)

Even downtown, many large snowstorms tended to blanket Red Lodge in the later spring months. This picture shows 6-foot drifts in 1934. Each decade, it seems, has its own legendary spring storms.

Development or wilderness? The caption on this undated photograph of Quinnebaugh Meadows, 5 miles beyond the end of the West Fork road, notes that the "Proposed dam [is] between the first two rocks" with a spillway to the left. No dam was ever built, nor did the West Fork end up as the route of the Beartooth Highway, as Al Croonquist had once sought. Today Quinnebaugh is a popular backcountry camping spot in the Absaroka-Beartooth Wilderness.

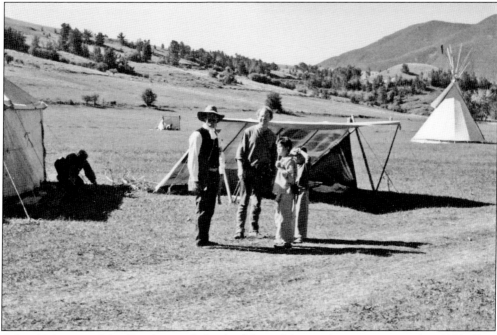

A local Mountain Man Rendezvous helped celebrate Montana's state centennial in 1989. Here *booshway* (boss) Jerry Fahrenthold is pictured in period costume at left with a visiting family. In its early years, the authentic 1830s-style encampment was held southeast of the Bearcreek bridge, with tepees lining a lane extending back toward Mount Maurice. Since then, historical reenactments have annual summer highlights in Red Lodge. (Courtesy Tressa Fahrenthold.)

Building on the popularity of the Beartooth Pass among motorcyclists, promoter Leo Wilson started an annual biker event, the Beartooth Rally and All-Harley Rodeo, in the 1990s. This Merv Coleman shot from atop the Pollard Hotel in 2006 echoes the one from the 1920s on page 46—except that now almost every vehicle on Broadway Avenue is a motorcycle rather than a Model A Ford. (Courtesy Merv Coleman, Coleman Gallery.)

Today historic tourism in Red Lodge starts at the Carbon County Historical Society and Museum in the restored Labor Temple building on north Broadway. Rotating exhibits cover ranching, skiing, ethnic history, and the Beartooth Highway, while a permanent installation in the basement includes a replica of actual coal and platinum/palladium mines.

Nine

CHARACTERS

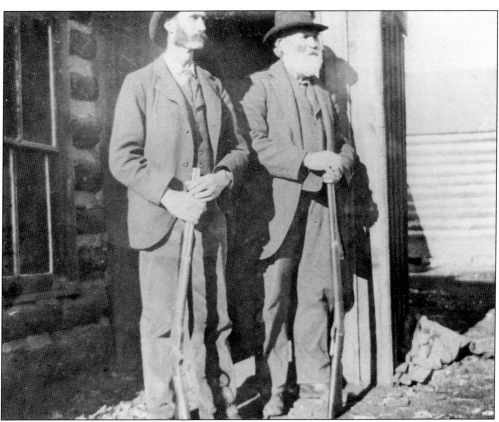

John "Liver-Eatin'" Johnston (1824–1900) served as the first constable of Red Lodge starting in 1895. He is shown here at right with an unidentified man. Despite the legends, including the 1972 Robert Redford movie *Jeremiah Johnson*, Johnston never ate any Native Americans' livers. Nevertheless, even as a 70-year-old constable, he was a fearsome man, capable of breaking up a fight by knocking the brawlers' heads together. He once said, "I just beat the hell out of the ones that should be arrested and turn 'em loose, and I've never had to arrest the same man twice!"

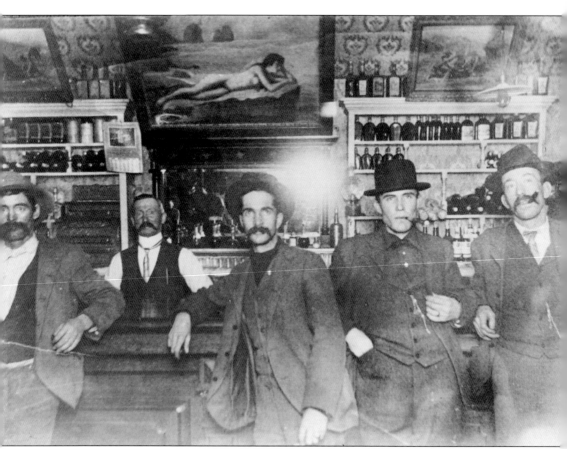

George Taff, pictured here standing behind the bar in 1900, was the proprietor of Taff's Holdup Saloon. In an era when few women frequented taverns, one of his regular customers was Martha Jane Cannary (1852–1903, better known as "Calamity Jane"). During these years, she lived mostly on the compassion of friends. In addition to her many controversial habits—she smoked, cussed, drank moonshine, wore men's clothing, and rode horses astride rather than sidesaddle—Calamity was also known for her generosity and great cheer. One friend recalled that she had the build of a blacksmith, the vocabulary of a muleskinner, and the tender heart of a priest. In 1901, when Calamity lay sick in the back room of the saloon, several prominent Red Lodge citizens took up a collection to help such a noted town character. However, by the time they got back to Taff's to give her the money, she had already left on a train to Billings.

In contrast to Calamity, Alice Adams Meyer represented the cultural sophistication of Red Lodge. Beginning in 1901, she met with a dozen other Shakespeare admirers for weekly evenings of reading and discussion. By 1903, this group evolved into the Women's Club, with Meyer as cofounder and patroness. In 1915, the club established the city's first library in the Savoy Hotel. It remained a driving force in Red Lodge for 75 years. For example, under the leadership of Gen Luoma and Norma Scheidecker in 1972, the Women's Club established the first bloodmobile in Red Lodge. A native of Wisconsin, Alice was married to banker, attorney, and state senator William F. Meyer. They arrived in Red Lodge in 1889 and 10 years later built a large Queen Anne–style home at 705 North Hauser Avenue in Hi-Bug. Its grand hall, boasting an oak staircase with a landing large enough to accommodate a string quartet, was the setting for many social galas.

Less is known of the frontier adventures of John W. Chapman (1850–1933) than readers might like, because, as an obituary put it, "He ever refrained from discussing his own exploits." As a rancher halfway between Red Lodge and Cody starting in 1880, he began with hardly any neighbors within 75 miles (the nearest post office was Bozeman). On two trips a year to Bozeman (and later Coulson, the predecessor of Billings), he and his plucky wife, Alphia, would get mail and supplies—their only contact with the outside world. Later he, William Meyer, and Paul Breteche founded a bank, which after Breteche's death became known as the Meyer and Chapman Bank, with Chapman as president. In the 1890s, he moved full-time to Red Lodge, building a large house next to the Meyers in Hi-Bug. The childless Chapmans were frequent entertainers, but their showplace home was poorly heated—every winter they moved into an apartment above the bank.

Packsaddle Ben Greenough (1869–1956) first arrived in Montana in 1886, working at a Billings hotel, where he bought wood from Calamity Jane. Calamity wrote in her diary, "He is young and green now, but some day I would not be afraid to stake my all on Ben Greenough." He worked for several big cattle and horse outfits, including Buffalo Bill Cody's Cedar Mountain Ranch, before homesteading north of Red Lodge to raise draft horses. Ben, his wife, Myrtle, and their eight children spent 1906 to 1923 in Billings before moving to a ranch south of Red Lodge, where Ben worked as a fishing and hunting guide. Liver-Eatin' Johnston gave him the name "Packsaddle" when he saw Ben riding his packhorse. Among Ben's many other talents was his ice-skating ability. He frequently gave exhibitions and set up a rink in the southwest area of Red Lodge. He is shown here in November 1939, when he was state figure-skating champion, with a young Mona Hagen (Nutting), who would serve as a Carbon County commissioner in the 1980s and 1990s.

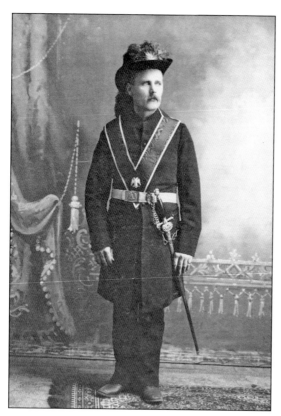

Jacob Kivikangas was one of the Knights of Kaleva, a secret society organized to preserve Finnish culture and tradition. He is pictured in full regalia in the early 1900s. A storekeeper, Jacob owned his own establishment for a while and later worked for the Carbon Mercantile and then managed the Kaleva Cooperative Mercantile. In 1912, he moved to a ranch near Fox where he farmed for 27 years. He died in Red Lodge in 1943.

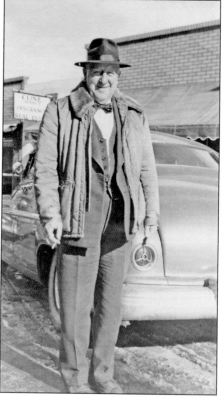

Dr. Edwin Adams (1882–1959) served as a Red Lodge physician and surgeon for over 50 years, 30 of them running a 25-room private hospital in a remodeled rooming house. The building, on Oakes Avenue between Tenth and Eleventh Streets, was torn down after construction of the Carbon County Memorial Hospital in 1951. In the 1920s, Adams and several other Red Lodge doctors would help their patients battle nerves and tension with prescriptions for alcohol.

Oliver H. P. Shelley (1875–1943), editor and publisher of the *Carbon County News*, was Red Lodge's chief lobbyist in the effort to develop the Beartooth highway. Shelley, a native of Kentucky, arrived in Red Lodge in 1924. A prominent Republican, he led the fight to secure a $2-million federal appropriation for the highway, making frequent trips to Washington, D.C. He had previously lived in Helena, where he was not so fondly remembered: in 1920, he rigged Montana's Republican presidential primary. At the time, voters selected convention delegates without necessarily knowing whom the delegates would vote for. Shelley recruited eight delegates whose names began with A, B, or D, and voters selected them from the top of the list. All eight voted for Shelley's candidate, progressive California senator Hiram Johnson, whose opponents fumed that O. H. P.'s initials should stand for One Horse Power Shelley.

Otto Jalmer "O. J." Salo (1895–1977) arrived in Red Lodge in 1897 as a toddler when his father, Mike, started work at the East Side Mine. An active socialist, Mike later worked at the Kaleva Co-op and several grocery stores. O. J., after service in World War I, worked as a guide and horse wrangler at Camp Senia, at the post office, as a Thor motorcycle dealer, and in the family's Beartooth Curio Store. Then, from 1934 to 1961, he was supervisor of county welfare. With Al Croonquist, he explored the Beartooths, stocking many lakes with fish and naming numerous features, including Lake Gertrude (near Timberline Lake) for his wife, the former Gertrude Dinsdale. In 1961, climbers from the University of Wyoming gave his name to a prominent peak in the Beartooths. Today, however, he's known primarily for having painted the murals of area scenery on display at the Red Lodge Café.

In addition to his role developing the Beartooth Highway, Dr. J. C. F. Siegfriedt (1879–1940) made many other contributions to Red Lodge. An Iowa native, Siegfriedt (known to most as "Doc") arrived in Bearcreek in 1906 and moved to Red Lodge in 1930. An avid hunter, fisherman, and zither player, Siegfriedt also served as a state senator and mayor of both Bearcreek and Red Lodge. As a doctor, he was not only dedicated and tireless but often forgot to send bills to his patients. As a mayoral candidate in 1937, he saw that gambling and prostitution—though illegal—were mainstays of the local economy and culture, so his platform planks included "bring in 20 more slot machines" and "start some new houses of pleasure." He won and served until his death three years later.

James F. Brophy is shown with a skull, probably from a cave explored by crews building the Black and White Trail. A mining engineer, Brophy ran the Smokeless and Sootless Coal Company near Washoe. He also discovered the area's first chrome on Silver Run Plateau and helped develop the Elk Basin oil field southeast of Belfry in 1913. His son, James R. Brophy Sr., ran the family coal mines for 27 years under the Brophy Coal Company name.

Rodeo champion Turk Greenough (1905–1995, also discussed in chapter 6) spent some time in Hollywood. He's shown here doubling for singing cowboy Tex Ritter in the 1939 feature *The Man from Texas*. He also served as a double for Roy Rogers, John Wayne, Tom Mix, Gene Autry, and Randolph Scott.

In Hollywood, Turk met burlesque star Sally Rand (1904–1979). Born Helen Gould Beck, she was given her new name by Cecil B. DeMille while acting in his silent films in the 1920s. In 1932, she created a fan dance that involved the careful placement of two seven-foot pink ostrich feather fans. Though it brought her international fame, Rand disliked the term "exotic dancer," saying, "The dictionary defines 'exotic' as that which is strange and foreign. I am not strange; I like boys. I am not foreign; I was born and raised in Hickory County, Missouri." Another photograph in the museum archives—involving Sally's bubble dance and too risqué for publication in this book—is inscribed to Turk, "To you, my love, this dream."

Turk and Sally's wedding, in Glendora, California, on January 6, 1942, was an exciting time for his hometown. The newlyweds moved to a spread south of Red Lodge that they dubbed Heaven Ranch and intended to run it as a dude ranch. But the marriage was short-lived, and they soon went on to other ventures. Turk was drafted and later returned to his first wife, Helen, moving with her to the Las Vegas area.

The wedding party for Turk and Sally's wedding included, at left, cowboys Bud and Bill Linderman. Next to Turk is his best man, actor Guinn "Big Boy" Williams, a frequent costar of Will Rogers who later specialized in roles as the somewhat dim and quick-tempered but basically decent sidekick. Right of Sally is her sister-in-law and matron of honor, Jovita Rand, and bridesmaids Alice and Marge Greenough. Wedding guests included cowboy actor Hoot Gibson and pioneering method actress Maria Ouspenskaya.

One of the area's hardworking ranchers was Don Kampfe, pictured here probably in the late 1940s. As urban job opportunities increased during and after World War II, those who chose to continue to make a living on a Montana ranch were usually tough, ornery, stubborn, romantic, and/or broke. Don, his descendants say, was neither romantic nor broke. (Courtesy Lazy E-L Ranch.)

Don's son, D. Frank Kampfe, sneaks up on a colt that's about to blow up. Notice how the horse's ears point back. Kampfe went on to become an attorney, perhaps best known for defending the "Red Lodge Five." That 1970s marijuana case spawned a write-up in *Playboy* magazine, much to the chagrin of his reputable in-laws. (Courtesy Lazy E-L Ranch.)

Harry Olcott poses with a FarmAll near his feed operation, the Carbon Implement Store, north of the train depot, probably in the late 1950s.

Tony Zupan is shown at his Ben Franklin store at 17 South Broadway around 1952. Zupan, once an aspiring professional golfer, spent most of his career as Carbon County clerk and recorder. He left county employment twice: once to run this store, and once to work at a bank. His wife, Shirley, former co-owner of the Sitzmark ski boutique, coauthored the landmark history book *Red Lodge: Saga of a Western Area* and cofounded the historical society.

Cleonice Favero, a beautician, started the Cleo-Marge Beauty Salon with Margarite McConville in 1933. The salon stayed in operation in the same downtown location for 58 years. Cleo was also active in the Italian Girls Victory Club, the Festival of Nations, and St. Agnes Catholic Church. When she retired in 1991, at age 85, she held the oldest active beautician's license issued by the State of Montana.

The girl in front on the horse is Glory Singleton (Mahan). After a career in California, Glory returned to Red Lodge in the 1990s to serve many years as a civic leader on city council, in service clubs, and most notably as Fourth of July parade director. Note the old Red Lodge State Bank building in the background, before it became the Waters department store.

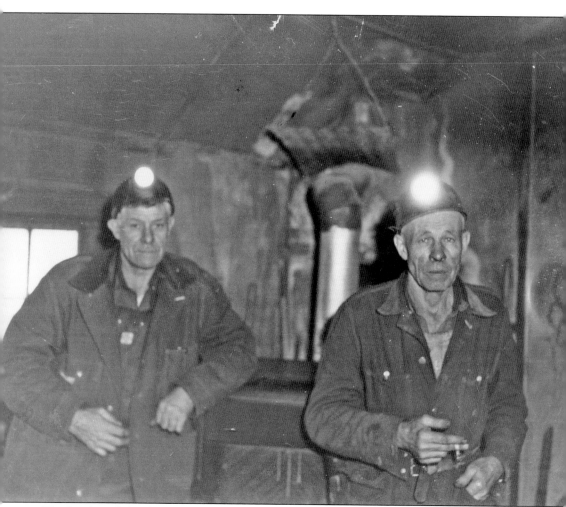

The Janskovich brothers operated one of the last coal mines in the Red Lodge area. This 1967 picture shows Leopold (Poly) with one of his brothers: Joe, Frank, or Tony. The Janskovich family moved to Bearcreek in 1906, but the boys' father, John, was killed in 1913 when he was thrown from a horse. He left a wife and seven children who made ends meet with a dairy farm. In the 1930s, the brothers acquired a mine near Bearcreek that they worked for 35 years with an outstanding reputation for safety and cleanliness. But around 1970, the state determined that the mine didn't meet regulations regarding proper machinery and air-conditioning and ordered it and the nearby Brophy mine shut down.

Known as "the hermit of the Beartooths," James "Jimmy Joe" Ayling (1904–1971) came to Montana from West New York, New Jersey, in 1925. He hunted elk and deer, built model ships from scratch, and corresponded with an orphaned Hong Kong girl he supported. During a blizzard in 1964, when he'd been caretaking the cabins at East Rosebud Lake, he fell and broke his hip; his dog pulled him over a mile to his cabin. In the late 1960s, he squatted on Forest Service land 18 miles up Rock Creek Canyon with his dogs, who would pull him in a red wagon (or, during winter, in a dogsled) for trips to town for groceries and socialization. His death represented a way in which history had come to view this community of individuals on a par with its spectacular natural setting. The *Carbon County News* wrote that Jimmy Joe was "a likeable character around town, and a sort of tourist attraction. Probably he's been photographed by tourists as much as any of the scenic mountains in this part of the country."

BIBLIOGRAPHY

Much of the information in this book comes from the files of the Carbon County Historical Society. Additional and published sources include:

Blevins, Bruce H. *An Early History of Red Lodge, Montana*. Powell, WY: WIMM, 1998.

Christensen, Bonnie. *Red Lodge and the Mythic West: Coal Miners to Cowboys*. Lawrence, KS: University Press of Kansas, 2002.

Clayton, John. "Cruising and Schussing: 40 Years at Red Lodge Mountain." *Montana Magazine*, November 1999.

French, Brett. "65 Years of Skiing: Silver Run Ski Education Foundation Marks Birthday with Fund-raiser." *Billings Gazette*, December 11, 2003.

Johnson, Charles S. "Montana Still Struggles to Have Say in Presidential Process." *Billings Gazette*, August 26, 2007.

Kulbacki, Michael, Bert McCauley, and Steve Moler. "An Orphaned Highway." *Public Roads*, Vol. 70, No. 1, July/August 2006.

Kusek, Joe. "Many Rodeo Champs Hail from Red Lodge." *Billings Gazette*, July 2, 2004.

Lampi, Leona. *At the Foot of the Beartooth Mountains: A History of the Finnish Community of Red Lodge, Montana*. Coeur D'Alene, ID: Bookage, 1998.

Mitchell, Kari. "Top of the World Party." *The Local Rag*, May 2004.

Transportation–Beartooth Highway vertical file. Parmly Billings Library, Billings, MT.

Wellington, Beverly. *Red Lodge Landmarks*. Red Lodge, MT: Carbon County Historical Society, 1992, 1995.

Zupan, Shirley, and Harry Owens. *Red Lodge: Saga of a Western Area Revisited*. Red Lodge, MT: Carbon County Historical Society, 1979, 2000.

INDEX

DISCOVER THOUSANDS OF LOCAL HISTORY BOOKS FEATURING MILLIONS OF VINTAGE IMAGES

Arcadia Publishing, the leading local history publisher in the United States, is committed to making history accessible and meaningful through publishing books that celebrate and preserve the heritage of America's people and places.

Find more books like this at
www.arcadiapublishing.com

Search for your hometown history, your old
stomping grounds, and even your favorite sports team.

Consistent with our mission to preserve history on a local level, this book was printed in South Carolina on American-made paper and manufactured entirely in the United States. Products carrying the accredited Forest Stewardship Council (FSC) label are printed on 100 percent FSC-certified paper.

MADE IN THE
USA